Atlanta

A Brave and Beautiful City

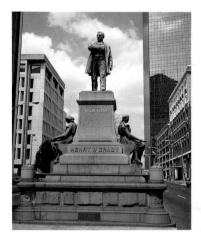

Atlanta
A Brave and Beautiful City

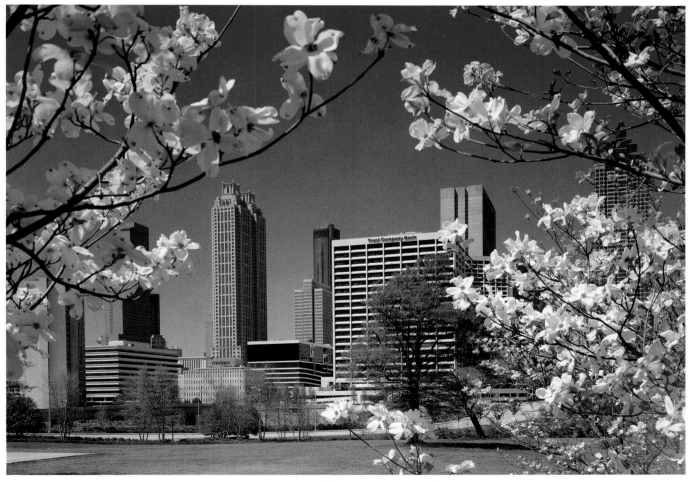

PHOTOGRAPHS BY PETER BENEY

with an introduction by Celestine Sibley

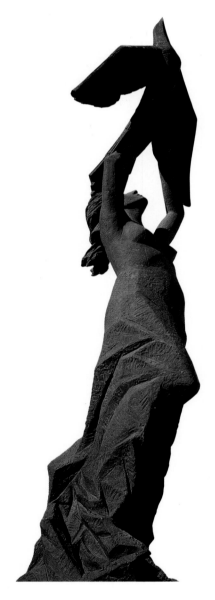

Phoenix Rising, by Gamba Quirino

PUBLISHED BY
Peachtree Publishers
494 Armour Circle NE
Atlanta, GA 30324

Manufactured in China

Text by Stephanie A. Thomas
Cover design by Terri Fox
Original interior design by Peter Beney
Revised interior design by Terri Fox and Jennifer Knight
Production by Loraine M. Balcsik

The publisher wishes to especially thank William H. Stender, Jr., for his financial support of this project.

First Printing
10 9 8 7 6 5 4 3 2 1

ISBN 1-56145-098-7
ISBN 1-56145-095-2 (pbk.)

Library of Congress Cataloguing in Publication Data

Beney, Peter.
 Atlanta : a brave and beautiful city / photographs by Peter
 Beney ; introduction by Celestine Sibley.
 p. cm.
 1. Atlanta (Ga.)--Pictorial works. I. Title.
 F294.A843B46 1994 94-18398
 975.8'231--dc20 CIP

Publisher's Note

Beautiful Atlanta: city of lush urban forests, blue skies, and stately architecture. Atlanta visitors have the opportunity to see only a fraction of the many subtle charms that the city offers and that residents know well. As we approach the 1996 Summer Olympic Games, many visitors from around the world will be interested in the rich history of Atlanta and its people.

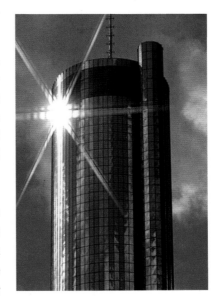

For these reasons, Peachtree Publishers wanted to release a new edition of *Atlanta: A Brave and Beautiful City*, which we first published in 1986. Atlanta deserves to be seen through the artistic lens of a photographer like Peter Beney. So we were delighted when he agreed to take another look at it for us. Our aim has been to select an array of images that portray the grace and good spirit of our lovely city for residents and visitors alike.

This book also includes a collection of brief stories that contain interesting details about the people and events that have shaped Atlanta. This is truly a city marked by destiny. The themes of renewal and rebirth echo throughout its history, and it is populated by people with vision and spirit and good hearts. We wanted to talk about these themes and people, to offer a glimpse of the color and personality of this place.

We hope that you like our view of Atlanta. We think it is an exceptional city.

Westin Peachtree Plaza

Introduction

*H*enry W. Grady said it first.

Back in 1886, the young editor of the *Atlanta Constitution* went to New York to address the New England Society. Bent on healing the wounds of the Civil War (he was credited with "loving a nation back to peace"), he had a message, he said, for General William T. Sherman, "an able man—though kind of careless with fire."

The message: "From the ashes he left us in 1864, we have raised a brave and beautiful city that somehow or other caught the sunshine in the bricks and mortar of our homes, and have builded therein not one ignoble prejudice or memory."

The little city of which Henry Grady was so proud was burgeoning, no doubt about it. Seven thousand people had voted in its last municipal election. It had attracted to its still somewhat sooty center a grand total of 303 business enterprises with an impressive payroll of more than two million dollars. And a Confederate veteran named John Pemberton was tinkering with a formula for what he hoped would be "a palatable syrup," soon to be called Coca-Cola.

Atlanta was on her way.

The phoenix, the bird of Egyptian mythology which burned to ashes and rose again in youth and beauty, was flapping its wings. People of the little town of Atlanta had heard about something they were determined to create for themselves. A diarist of the day called it "the good life."

A visitor in 1848 recorded in his journal that he had never seen "more beauty than there was in the springtime in the groves all over Atlanta." He waxed poetic about the "lavish luxuriance" of flowering plants, great trees and crystal streams, and then he said it again: "I have seen few things so fair in this world of beauty as were the Atlanta woods in 1848."

Atlanta's woods have receded somewhat before the march of building and growing, but the reverence for beauty abides. Atlantans liked that view of their town in 1848, and they ardently cherish it today. In the midst of spreading out in all directions with its subdivisions and office complexes, and reaching upward with its skyscrapers and the second busiest airport in the world, Atlanta is dotty about its trees and gardens.

It stages annual festivals to celebrate the glory of the dogwood, which trims its streets with a ruching of starchy white and delicate strawberry pink lace in the spring. It fights to preserve its old trees with city ordinances and vigilant citizens groups, and it constantly plants new trees—along the sidewalks and roadways, in concrete boxes downtown, anywhere there is a patch of hospitable earth.

Before the usually benign winter has passed, garden tours and flower shows have started. Camellias are blooming and azaleas girding up for that most flamboyant of early spring carnivals of color. Tulips are on the way, iris and roses follow, and the bounty of summer flowers fills humble dooryards and the grounds of great estates. Even after the tawny tide of chrysanthemum color has subsided in the fall, Atlantans are thinking or planning or dreaming of gardening. They study it in classes at the Atlanta Botanical Garden or in Piedmont Park. They take horticultural courses at Emory University or travel to Athens to the University of Georgia's world-famous school of landscape design to learn serious things about drainage and grading of gardens.

*T*he natural beauty of the foothills of the Blue Ridge mountains was Atlanta's legacy at birth. But catching the sunshine in the brick and mortar of its buildings,

as Henry Grady put it, was another matter. In the antebellum Southern colonial mansions which Sherman missed—and there are enough of these still around to be seen in home and garden tours—the openness to the out-of-doors was there. Long galleries and balconies were traditional and floor-to-ceiling windows invited light and air. The celebrated Neel Reid, whose mansions are cherished as showplaces among the estates of the north side and the splendid homes of Druid Hills, was the first of many architects to bring light and grace and symmetry to the brick and mortar of Atlanta homes and public buildings.

There's an old story, most certainly apocryphal, that back when Atlanta had a dearth of good restaurants and only a few notable hotels, some well-to-do citizen excused it by saying, "What do we need with restaurants and hotels? If a gentleman comes to town, he is welcome in our homes. If he isn't a gentleman, he isn't welcome at all."

That attitude, if in truth it existed, has long since vanished. Atlantans rejoice in a thriving tourist business and are pleased to offer variety and splendor in such landmark hotels as John Portman's original Hyatt Regency and the seventy-six-story mirrored tower, the Westin Peachtree Plaza. And whether the visitors are domestic or from foreign lands, they have no trouble finding cuisine to suit them.

The visitor in 1848 was impressed by Atlanta's "crystal" water, much of it contained in the storied Chattahoochee River which curves around the city on its way to the Gulf of Mexico. That water has been put to maximum use, not only for drinking but for recreation as well, entrapped in two tremendous lakes north of the city where it offers sites for weekend and vacation homes and all water sports. (An inland city, Atlanta claims one of the biggest yacht clubs in America.) The river itself, still beautiful despite the bridges that crisscross it and the apartments and homes which overlook parts of it, is also handy for rafting, canoeing, fishing and camping. There are ski resorts in the mountains within an easy drive of Atlanta and more than thirty golf courses in the area. One of these, the Atlanta Athletic Club, home club of famed grand-slammer Bobby Jones, has hosted the U.S. Open in years past.

*H*enry Grady wasn't into golf, of course. But he would have seen the wisdom in building so many of these richly rolling acres of green. After all, there's Atlanta's incomparable weather—an estimated 225 "good golfing days" a year.

Peter Beney found plenty for his camera to do in Atlanta, recording here examples of the vitality, the "sunshine," the energy and aliveness.

Henry Grady would be very proud.

Celestine Sibley

skywriting the Olympic rings

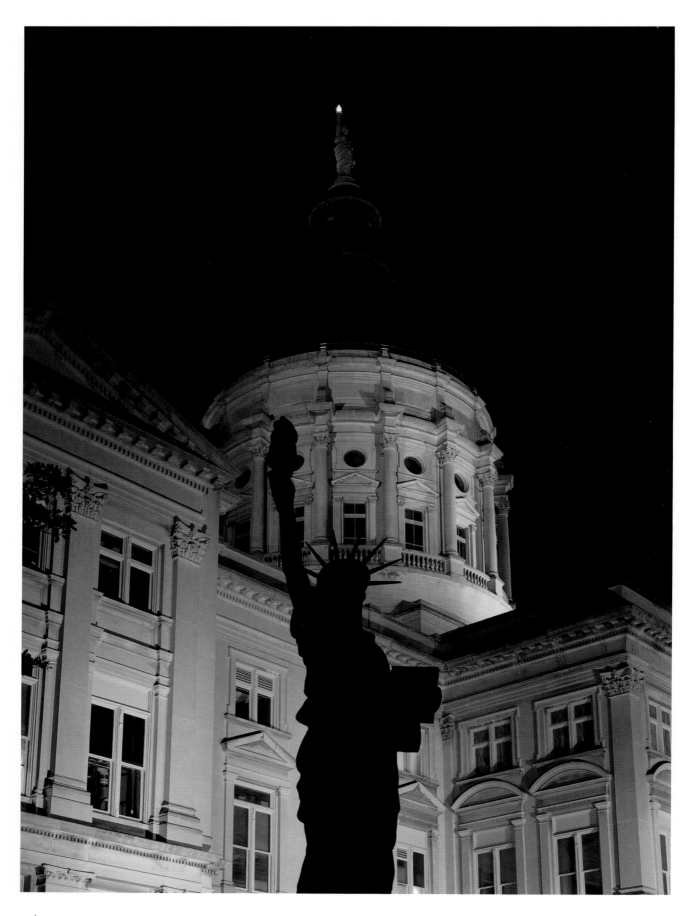

Georgia State Capitol Building

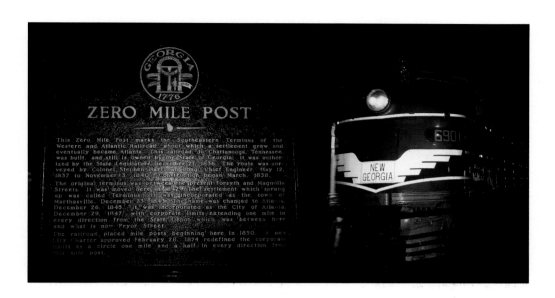

*Q*uite by accident, a railroad helped found the city of Atlanta. When the Western and Atlantic Railroad was just beginning, its planners were not exactly certain where the line should terminate. Stephen H. Long set out to find the best location for the end of the rail line; in September of 1837, he drove a stake just to the east of the Chattahoochee River to mark the terminus of the railroad. He thought that this stake, known afterward as Zero Mile Post, designated only the end of the W&A Railroad, but it actually marked much more—the beginning of Atlanta.

A village quickly grew around Zero Mile Post to support the growing numbers of railroad workers. The town became known as Terminus because of its relationship with the railroad, but it soon outgrew its end-of-the-line name. Less than ten years after the post was driven, the town had grown into a transportation hub where three rail lines intersected. The name Terminus was changed to Marthasville in 1843 in honor of former governor Wilson Lumpkin's daughter. This name, however, was not destined to last long either.

According to informal history, the railroad workers at the now-bustling depot at Zero Mile Post complained heartily about the trouble of writing the long name "Marthasville" on each and every ticket and bill. The W&A Railroad decided to change the depot's name to a shorter word, choosing "Atlanta," most likely considering the word a feminized version of "Atlantic." Soon after the depot changed its name, the post office followed suit; the city itself officially adopted the name Atlanta in December, 1845. Over a century and a half has passed, and Atlanta it has remained, with Zero Mile Post acting as both the literal and symbolic center of the city and a tangible link to its past.

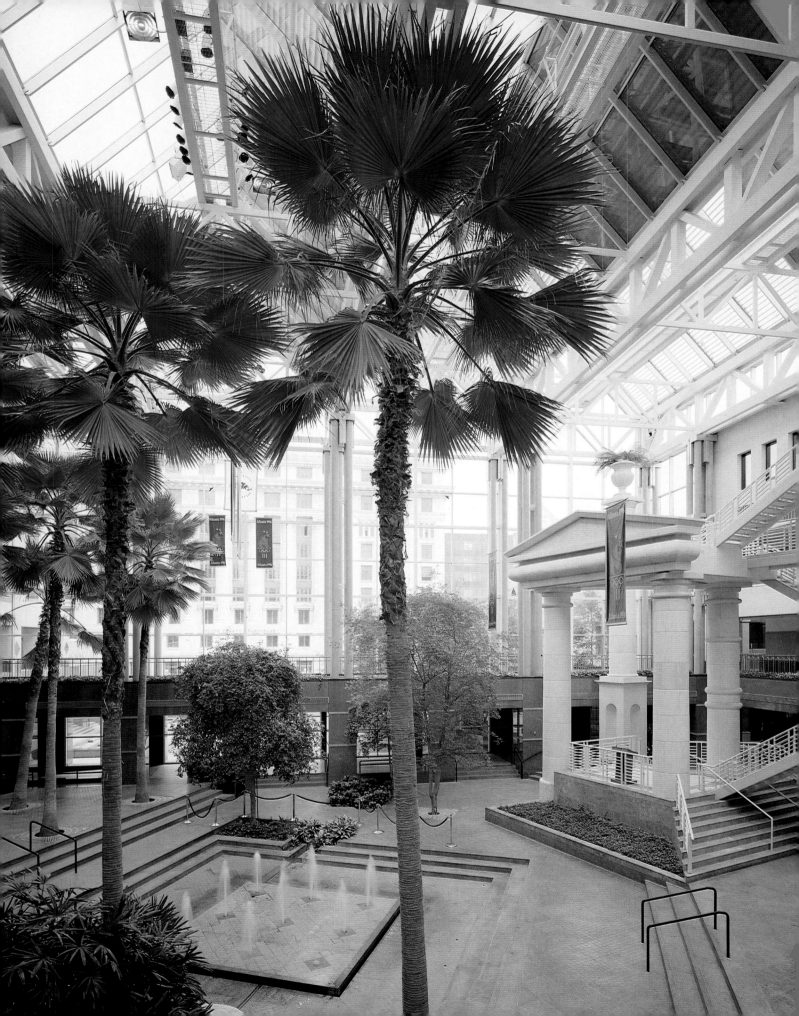

*F*rom 1861 to 1865, the Civil War engulfed the United States. Thirteen southern states seceded to form the Confederate States of America, sparking the bloodiest conflict in American history. One of the most devastating events for the Confederacy was General William T. Sherman's March to the Sea. In this campaign, Sherman's troops burned a path from Atlanta to the Atlantic Ocean, ravaging the land and effectively cutting the Confederacy in half.

Sherman's March to the Sea began in Atlanta; the once-thriving city was little more than ash when the Union troops left. But Atlanta turned its own destruction into resurrection. Newer and bigger buildings were constructed to take the place of those that were burned; the rail lines were repaired and eventually expanded; families and businesses returned and reestablished themselves.

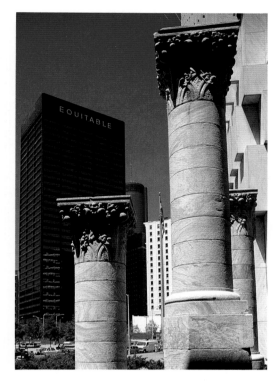

On September 19, 1887, Atlanta adopted a new city seal to reflect its past and its future. The seal's main image is a bird, its wings outstretched, rising from flames. This bird is the phoenix, the legendary creature who perishes by fire in its nest, only to be reborn from its own ashes. Above this image is the Latin motto *Resurgens*, which translates as "rising again." Two dates rim the seal: 1847, the date of Atlanta's incorporation, and 1865, the year the Civil War ended and Atlanta's rebirth began. Atlanta literally reconstructed itself out of its ruins, living out the phoenix legend on a citywide scale. This symbol has remained ingrained in the city's psyche ever since.

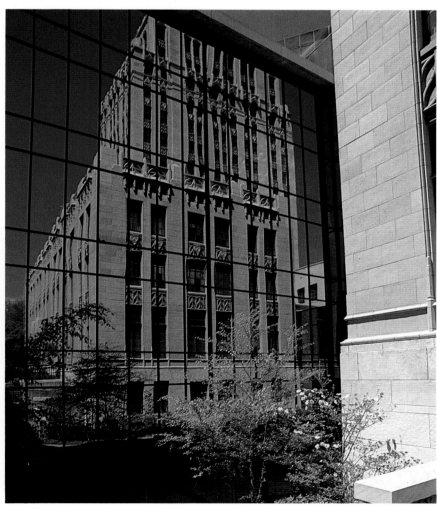

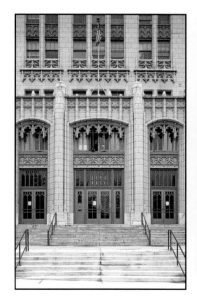

opposite: atrium, Fulton County Government Center
top: columns of the old Trust Company of Georgia building
bottom left: Old City Hall facade
bottom right: reflection of Old City Hall in New City Hall

5

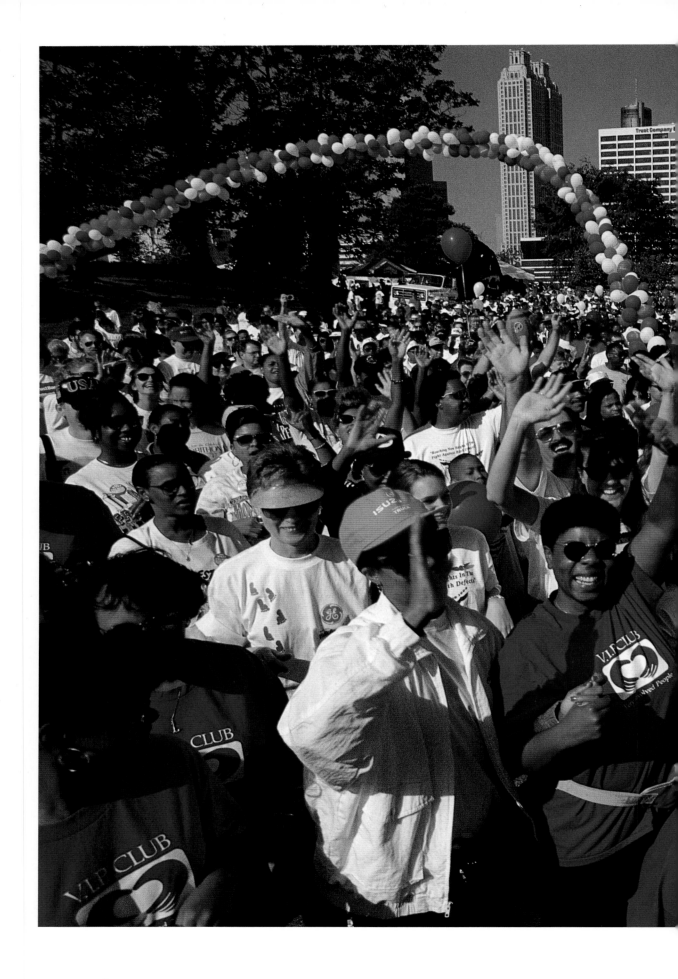

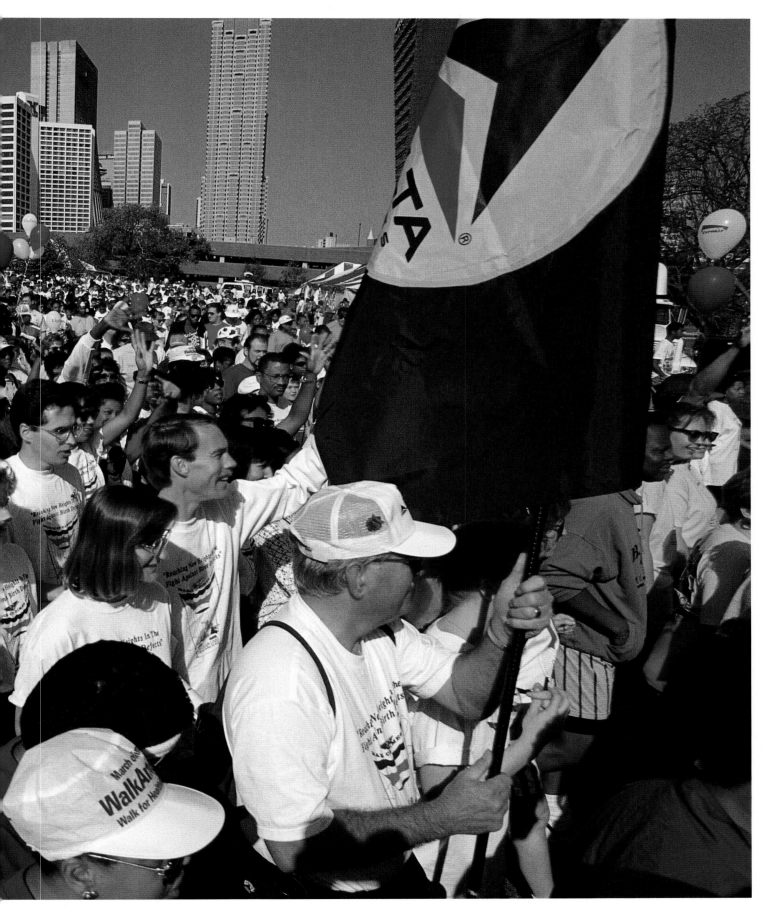

Walk America walkathon, Georgia Power Park 7

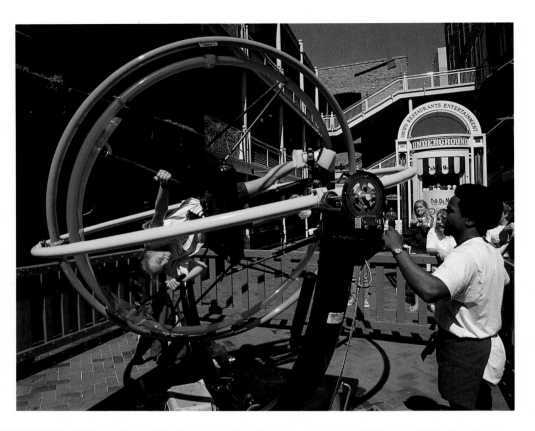

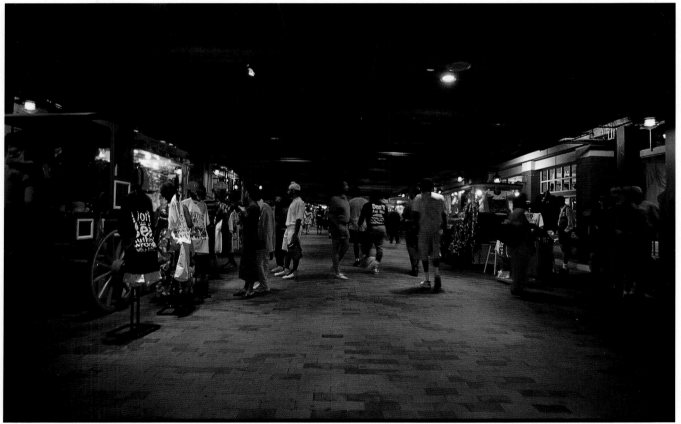

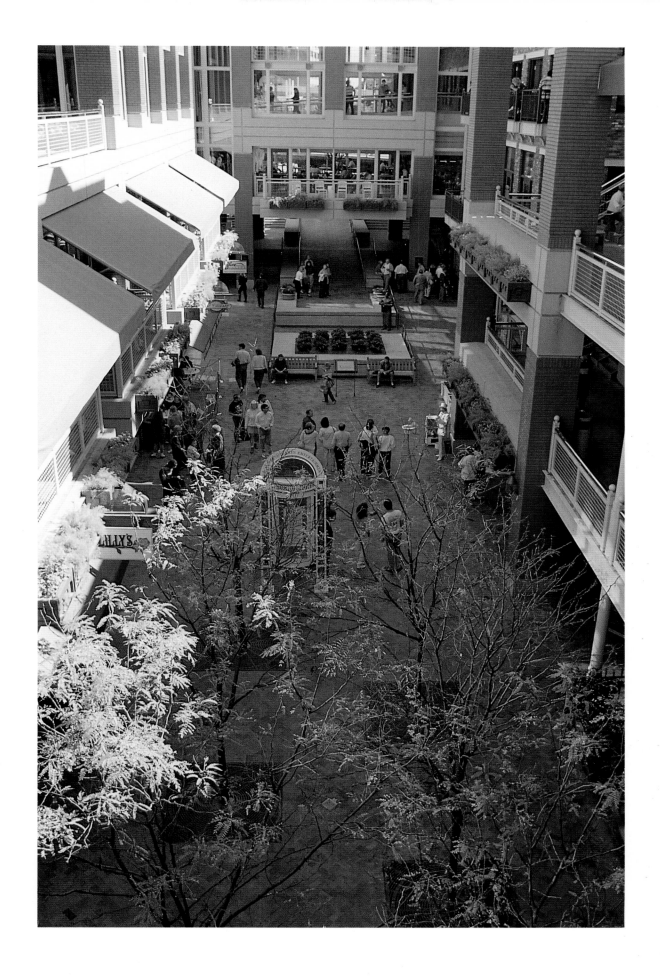

What is now Underground Atlanta was once the heart of the business district of antebellum Atlanta. The area underwent its first transformation in 1864 when General William T. Sherman's Federal troops burned most of its buildings. Atlanta rebuilt after the Civil War, but the automobile was soon to bring changes that would profoundly alter the area. Viaducts were built over the railroad tracks in the 1920s to accommodate ever-increasing traffic. This new construction created an entirely new street level, literally covering over the old streets and storefronts below. Older businesses, now underground, sank into a slow decline, eventually becoming little more than abandoned warehouses.

This forgotten space was transformed into an entertainment complex called

Underground Atlanta in 1968. The first effort to reclaim the area failed, with financial problems forcing Underground to close in 1980. In the long-standing Atlanta tradition of turning problems into assets, the old Underground gave way to a revamped Underground, which opened in 1988. This six-city-block complex lies approximately twelve feet below present day street level; visitors can stroll along the brick and stone streets and stop in the many restaurants, shops, and kiosks in the subterranean setting. Underground Atlanta has become a favorite gathering place for locals and visi-

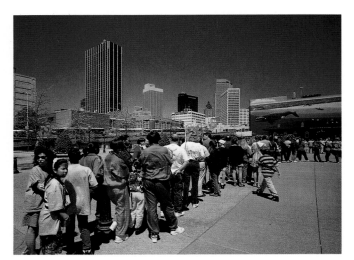

tors; residents gather for important events such as New Year's Eve, while tourists flock to Underground for the shopping, dining, and the nearby World of Coca-Cola pavilion.

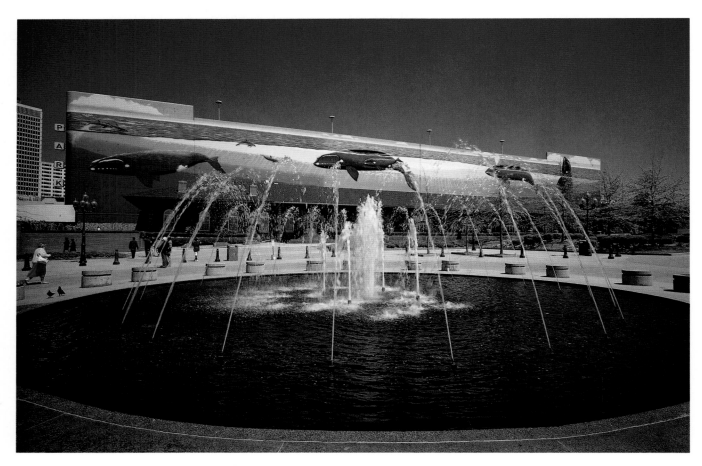

above: Steve Polk Plaza, outside the World of Coca-Cola museum
opposite: entrance, World of Coca-Cola museum

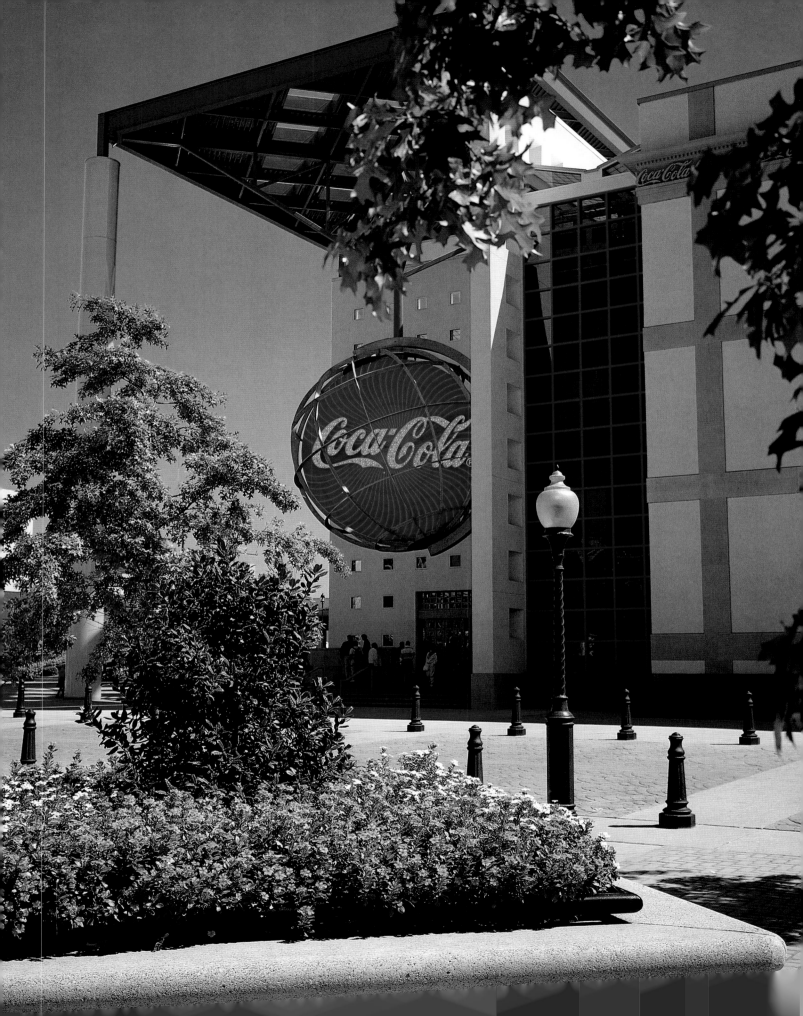

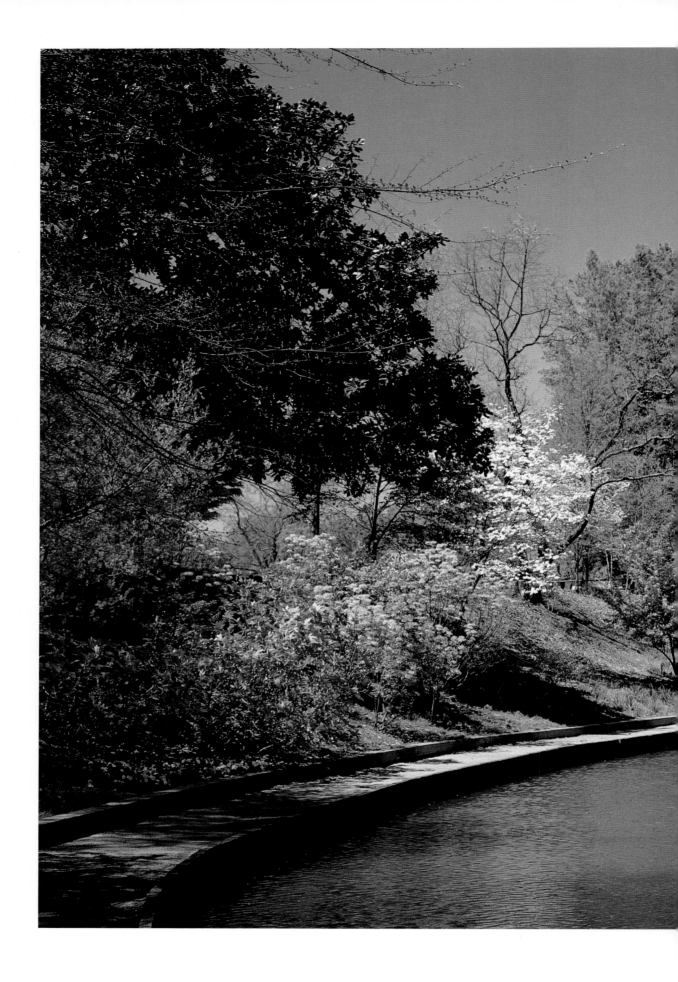

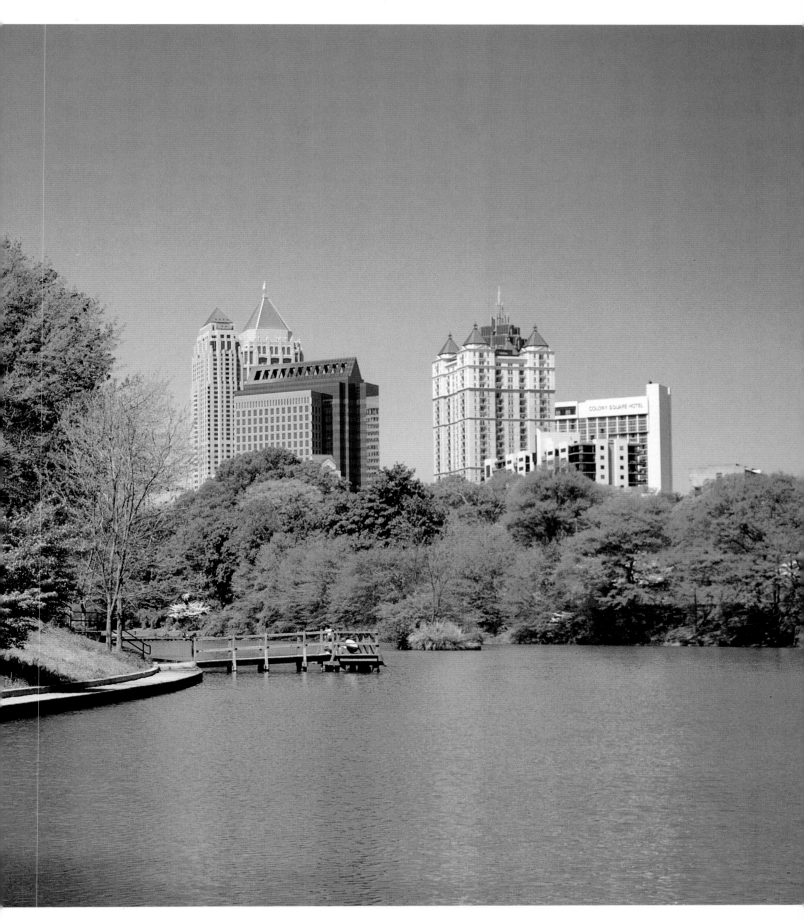

midtown skyline from Lake Clara Meer, Piedmont Park 13

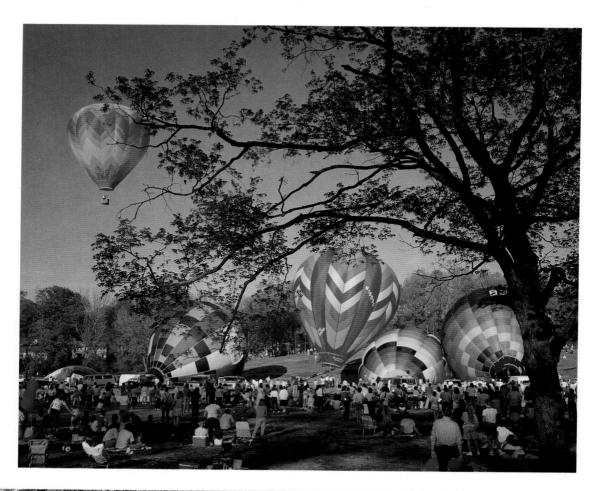

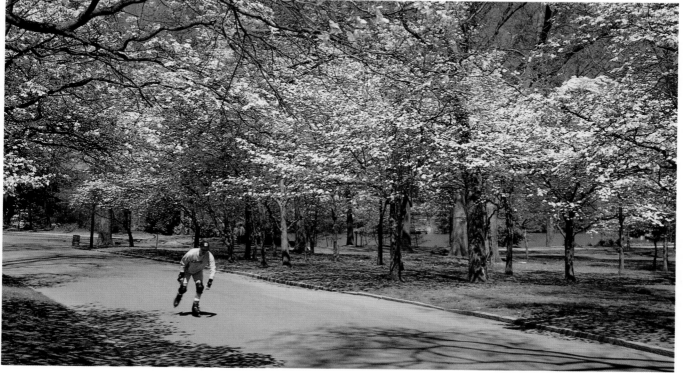

Piedmont Park, midtown

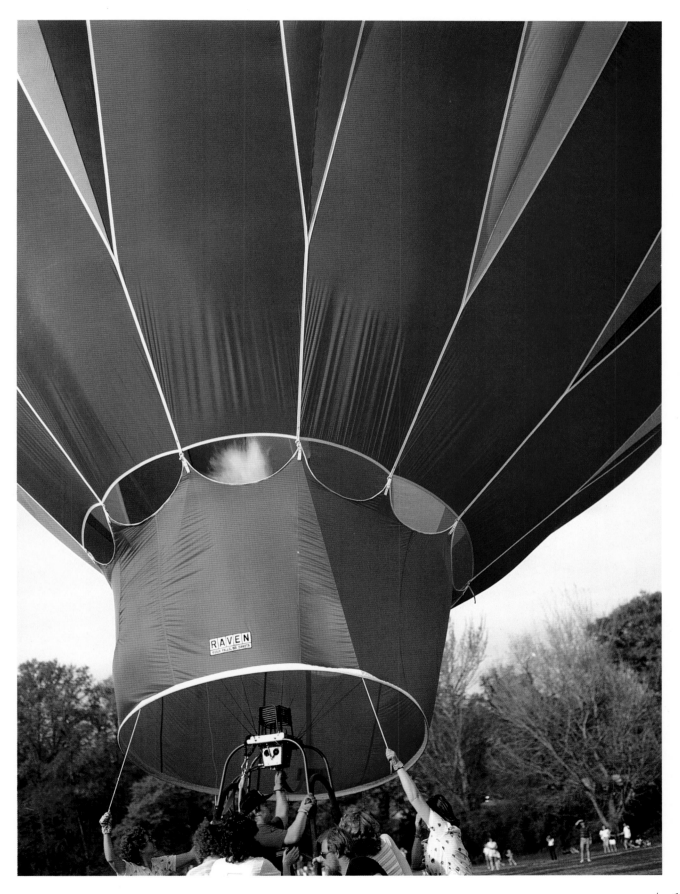

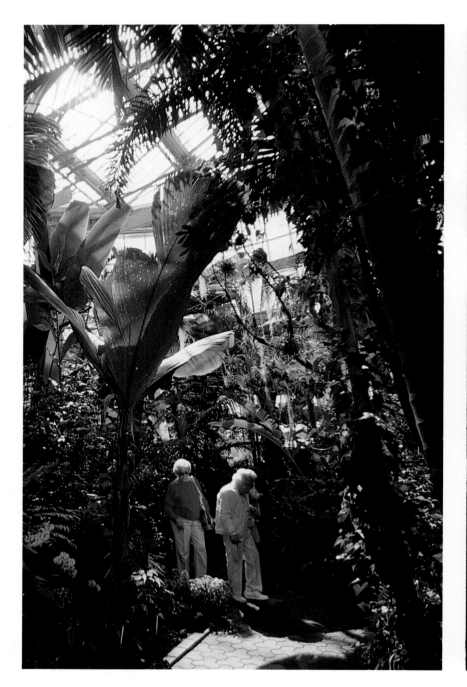

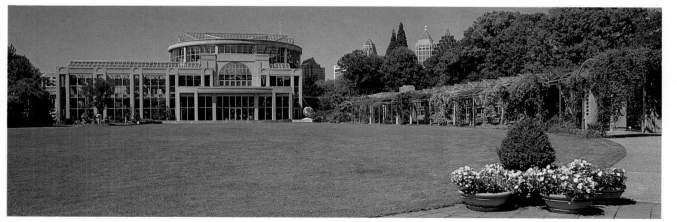

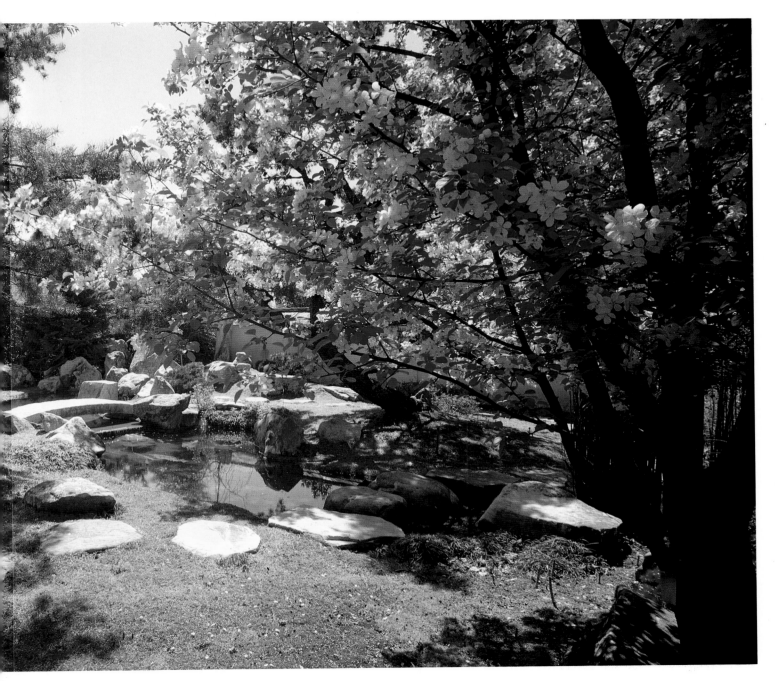

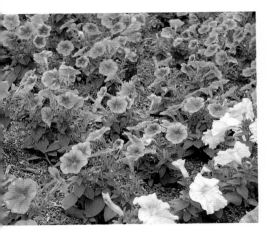

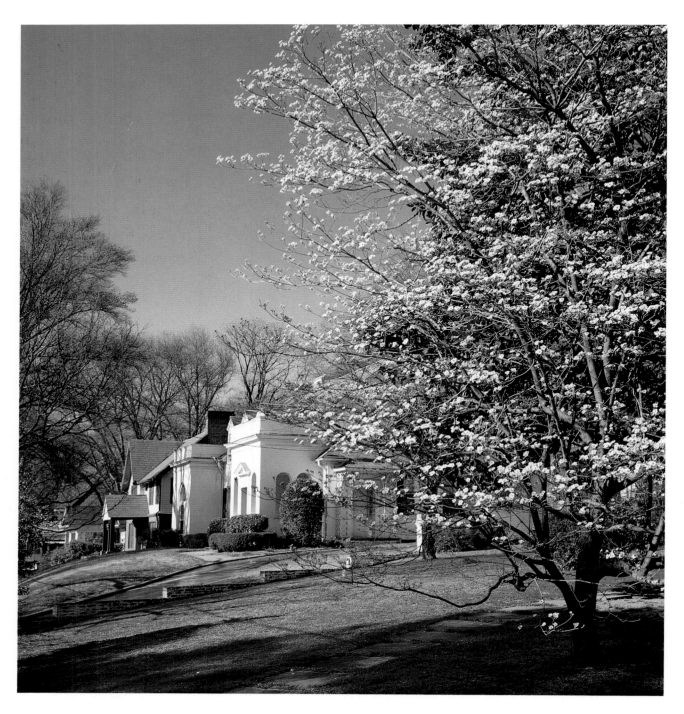

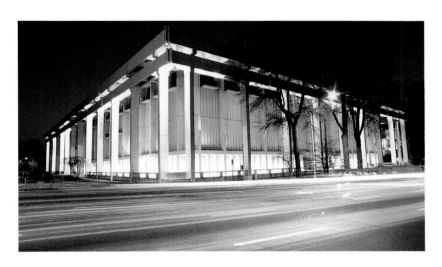

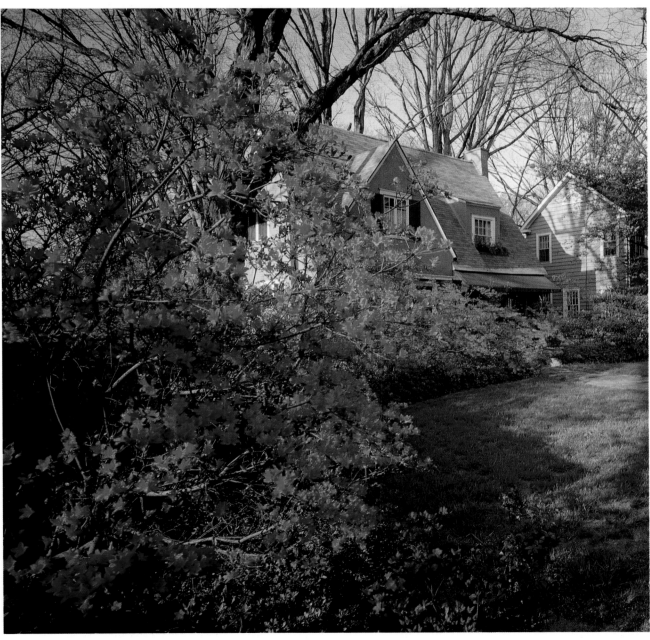

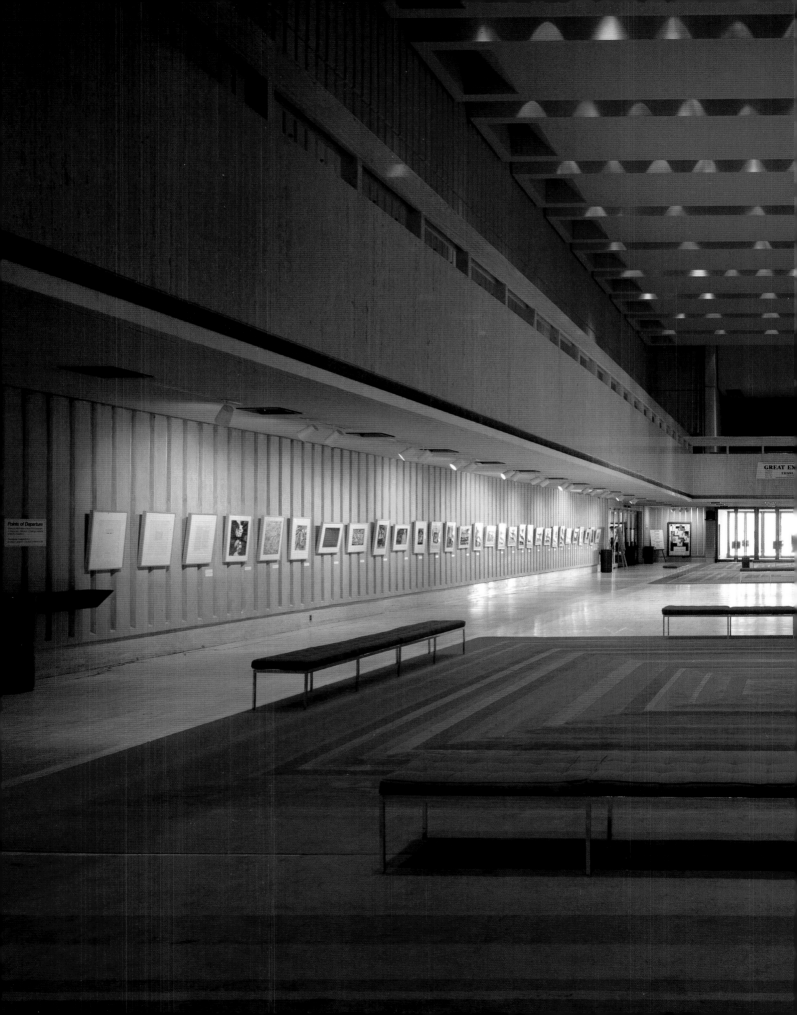

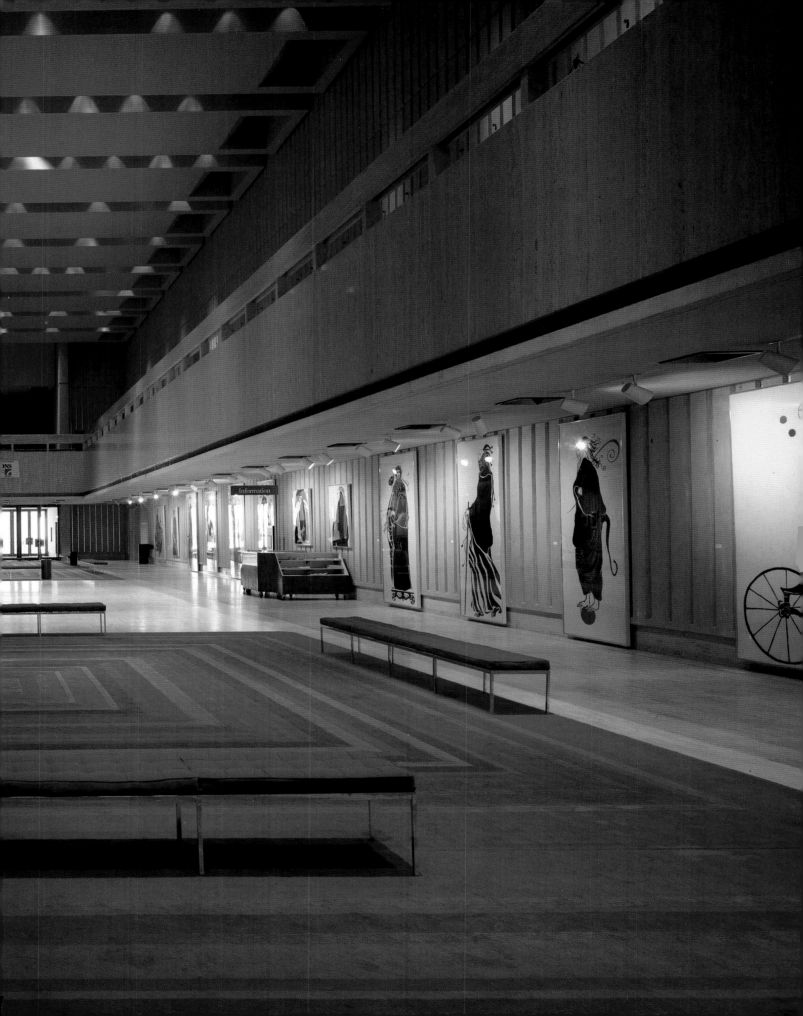

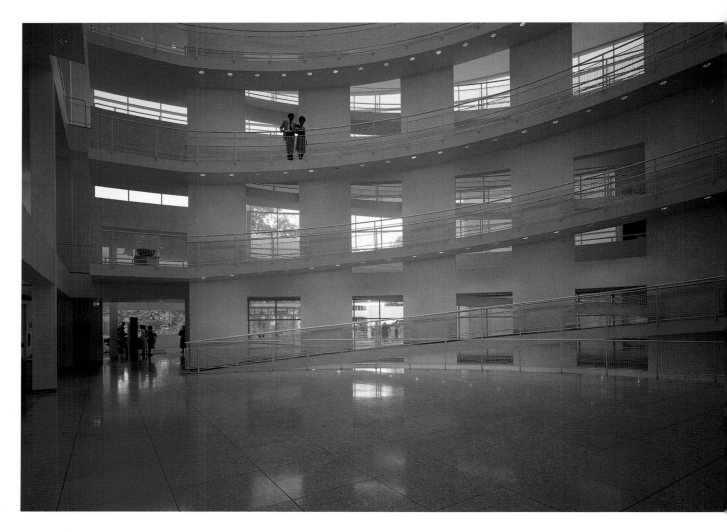

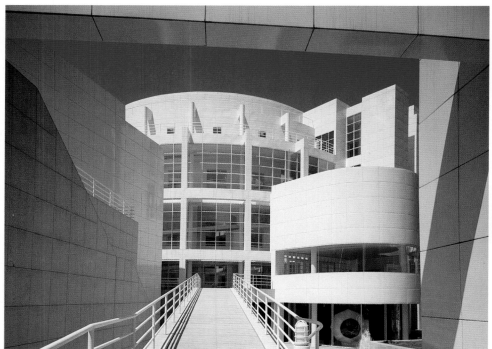

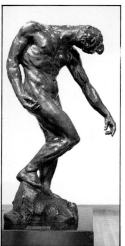

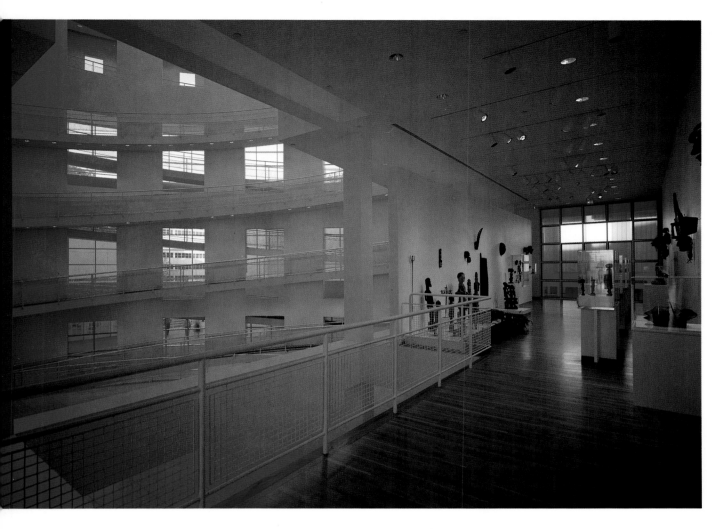

*T*wenty years after a plane crash in Orly, France, claimed the lives of 106 Atlanta Art Association members, the Atlanta Memorial Arts Center was dedicated in their memory. The Rodin statue that holds a place of honor at the museum stands as a reminder of that sorrowful day of June 3, 1962. *The Shade* (pictured on the previous spread) was given to the Atlanta Art Association by the French government as an expression of sorrow for those art patrons lost in the crash.

The Art Association had been founded in 1905 with a mission to build a museum for Atlanta. It accomplished this goal in 1926 after Mrs. Joseph High donated her former home on Peachtree Street to serve as a site for the building. Part of the reason for the fateful European tour in 1962 was to visit museums to gather ideas for the building of an expanded Arts Center in Atlanta.

Many of the city's leading citizens were lost in that crash. In the aftermath of the tragedy a new Atlanta Arts Alliance was formed and money was raised to fund a larger complex, like the one envisioned by the Art Association. This new complex opened on June 3, 1982, with a wreath-laying ceremony at the foot of *The Shade*; Alliance President Charles R. Yates dedicated the building, saying, "Just as the coat of arms of the City of Atlanta pictures a phoenix rising from the ashes of a burned city to symbolize its rebirth, so has the memory of our friends been our symbol…in helping the kind of institution which they cared so much about, to rise from the ashes of Orly."

*A*n early supporter of the new Arts Alliance, and indeed Atlanta's most famous philanthropist, was Robert W. Woodruff, the Coca-Cola magnate. Woodruff breathed life into the fund-raising effort that followed the tragedy of Orly with an initial gift of four million dollars. This particular gift was small in light of the total monies donated by Robert Woodruff to the Art Center (later renamed in his honor) and to other Atlanta institutions.

Known for years as Mr. Anonymous, Woodruff worked behind the scenes to create a solid foundation for Atlanta's important institutions. One of the major recipients of Woodruff's generosity and vision is Emory University. In 1986, he transferred Coca-Cola stock valued at $100 million to Emory. This gift has enabled Emory to become one of the nation's best educational institutions.

Another generous contributor to Atlanta's cultural and educational life is Michael C. Carlos. The Emory Museum of Art and Archaeology was renamed the Michael C. Carlos Museum in acknowledgment of his major contribution of four and one-half million dollars for the

Museum's renovation in 1992. Although he is a lifelong resident of Atlanta, Mr. Carlos's Greek ancestry informs his passion for the museum, which includes a collection of ancient Greek art.

A city is made great by its patrons and volunteers. And Atlanta has a rich abundance of men and women like those described here who commit their time and resources to enhance the culture and the beauty of this great city.

While the Reverend Dr. Martin Luther King, Jr., lived his life before the eyes of the world, he began and ended his life's journey in Atlanta. Born on Auburn Street on January 15, 1929, Dr. King grew up in the Sweet Auburn neighborhood, worshiped in Ebenezer Baptist Church where his father served as minister, and attended Morehouse College. King eventually settled in Montgomery, Alabama, and began his career as a preacher and an activist.

Dr. King's message, both to his congregation and to civil rights activists, was one of justice. He advocated nonviolent protest as a means of social change, much in the same vein as Henry David Thoreau and Mahatma Gandhi. In 1964, the international community acknowledged the significance of his message with the Nobel Peace Prize. Dr. King's efforts also were instrumental in making the 1964 Civil Rights Act and the 1965 Voting Rights Act reality.

After Dr. King was assassinated in Memphis in 1968, the world came to Atlanta to see him laid to rest. After the funeral ceremony, which was held in Dr. King's father's church, a mule-drawn wagon bore the coffin through the streets of Atlanta amid masses of mourners. Dr. King was laid to rest in what is now the Martin Luther King, Jr., National Historic Site and Preservation District; this area includes King's birth home, almost sixty-eight acres of the surrounding neighborhood, and the tomb itself. The Martin Luther King, Jr. Center for Nonviolent Social Change, founded by Dr. King's widow, Coretta Scott King, is also based here, and is devoted to fostering the ideals for which King lived and died.

Martin Luther King, Jr., National Historic Site and Preservation District
overleaf: bedroom of Martin Luther King, Jr., Birth Home

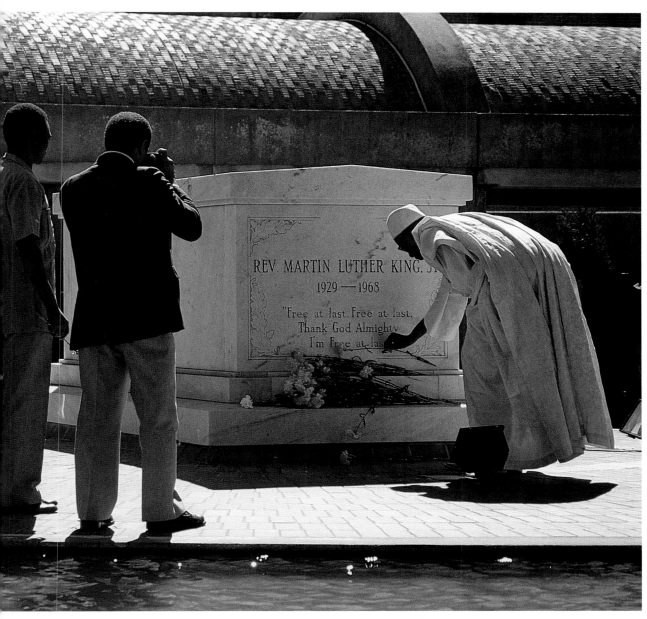

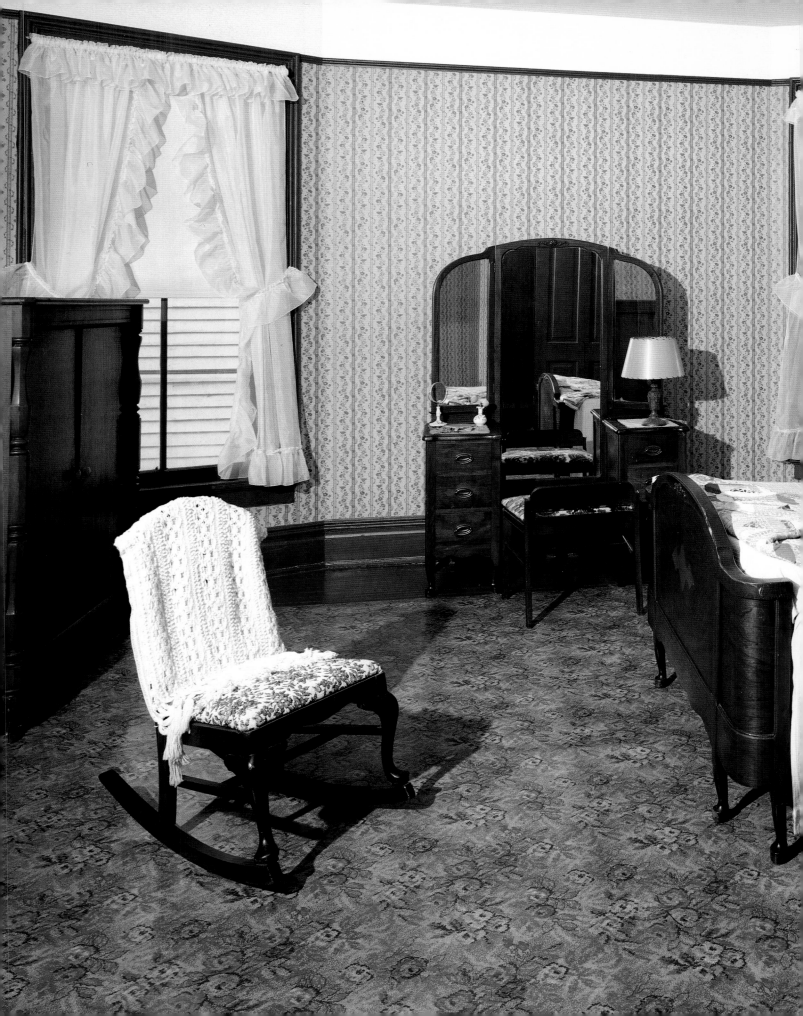

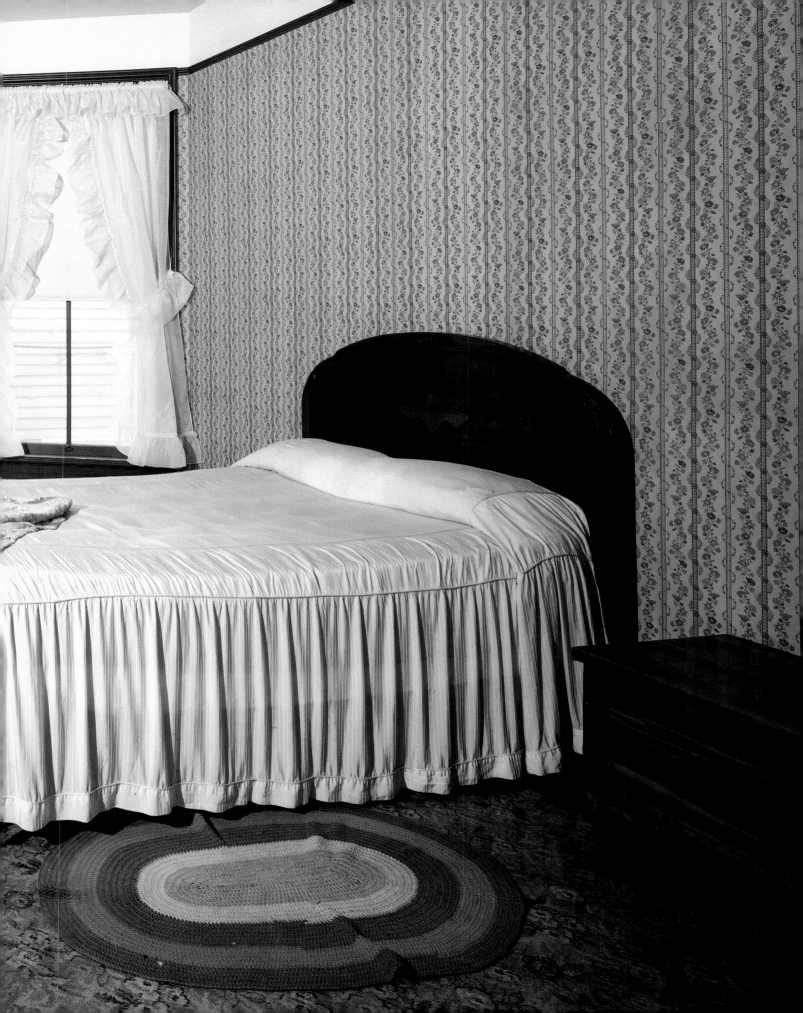

James Earl Carter, Jr., the thirty-ninth president of the United States, is not an Atlantan by birth, but Atlanta was his base as governor of Georgia and later his headquarters when he launched his bid for the presidency. Now Atlanta is the home of The Carter Center, which houses the Presidential Library and Museum, and a research and educational institution affiliated with Emory University. It is from here that world-renowned leader Jimmy Carter and his wife and partner Rosalynn Carter continue their work for human rights, political stability through conflict resolution, and health education.

One of the many programs of The Carter Center is GLOBAL 2000, which is devoted to improving the quality of life in developing countries by providing health and agricultural services and education. Here at home, The Carter Center has launched a community-wide effort to attack social problems associated with poverty in urban areas. This grassroots program is called The Atlanta Project. It draws strength and substance from the individual volunteers now numbering over one million people—within and outside the urban communities—who commit their time and energies, in partnership with private and public organizations, to addressing the complex problems of the urban poor. The Atlanta Project will serve as a model for other communities across the nation with pilot programs already underway in a number of U.S. cities.

Jimmy and Rosalynn Carter represent the best qualities of Atlanta and the South—personal warmth and humility paired with ambitions that achieve great goals, and adherence to a moral code that dignifies their neighbors and elevates the meaning of community. Atlanta is greatly enriched having the Carters within its community.

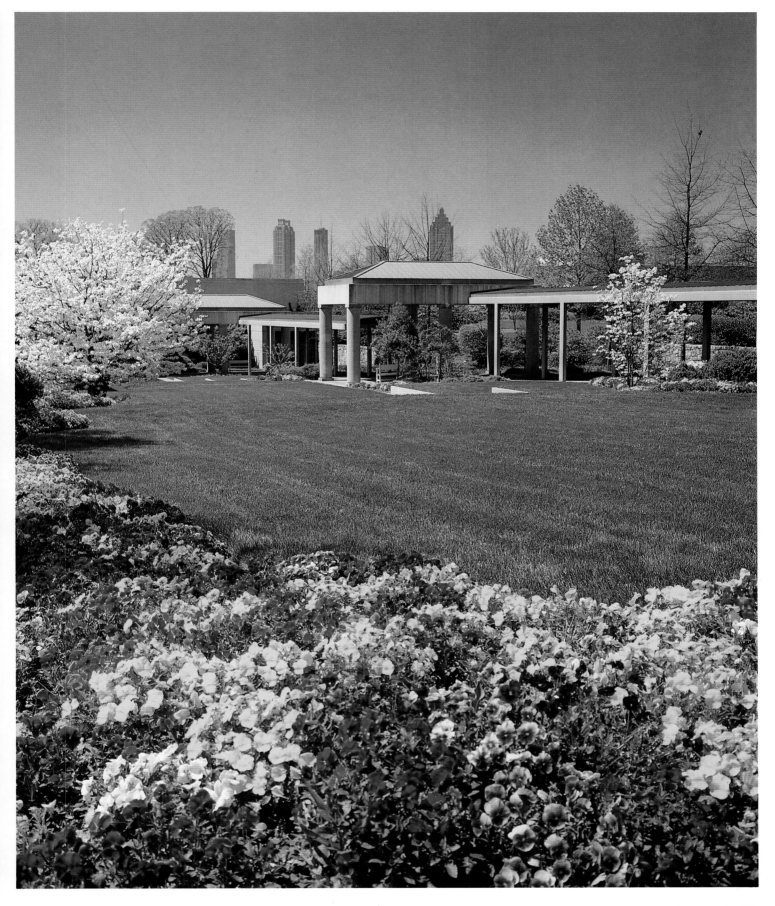

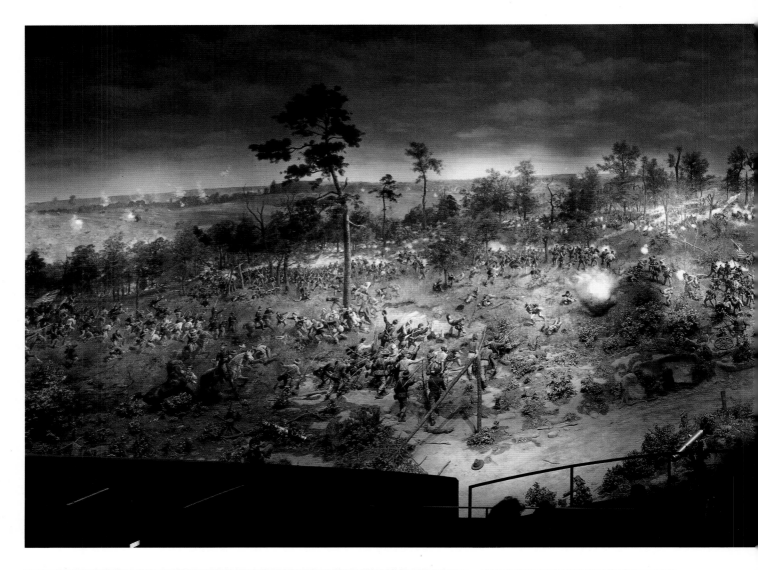

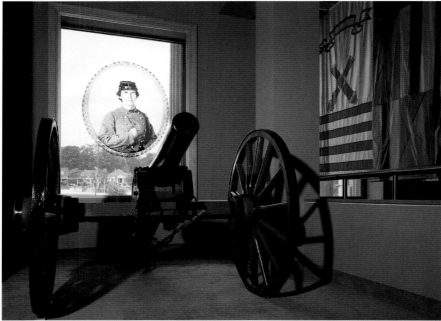

top: Atlanta Cyclorama
bottom: Civil War Battle of Atlanta Museum

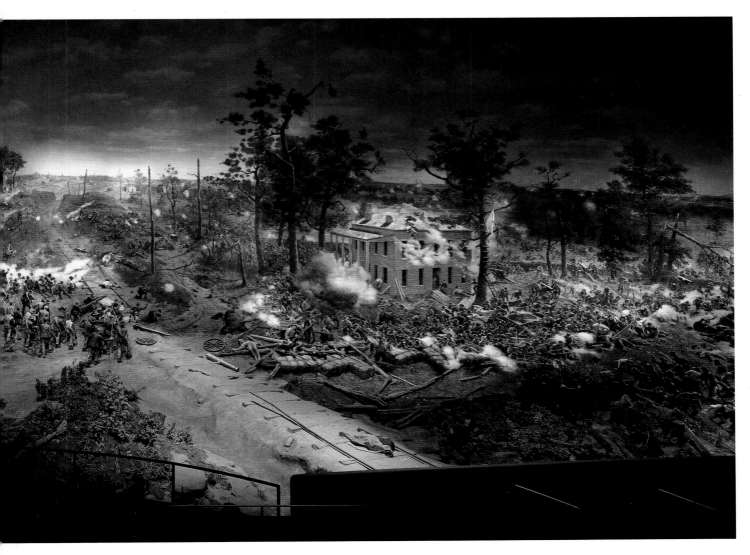

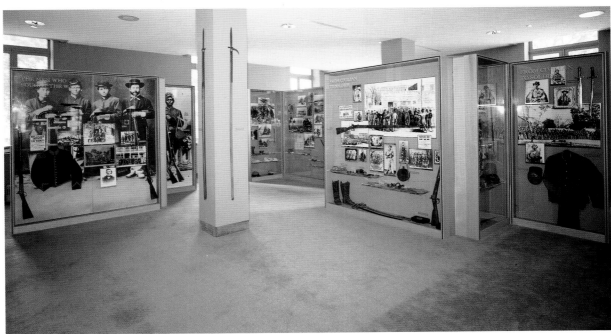

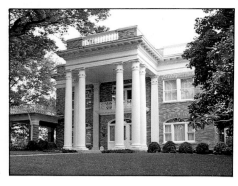

*A*lmost 3,000 Confederate casualties of the Civil War, many of them unidentified, are buried in a special section of Oakland Cemetery. In this same section lie twenty Union soldiers, all of whom died while patients in Confederate hospitals. The proximity of these wartime enemies may sound unusual, but it was actually a necessity of the times. Oakland, which was established in 1850, was the only public burial ground in Atlanta until 1885. Thus, the soldiers were forced to share in death the land they fought to control in life.

The Union and Confederate neighbors are not the only outstanding inhabitants to be found within Oakland's eighty-eight acres. For many

years, Margaret Mitchell's headstone was found easily because of an annual springtime array of tulips. The tulips arrived every year for fourteen years, donated by a Dutch publisher who had known the author. This tribute ended only when overeager *Gone with the Wind* fans began digging up the bulbs as souvenirs. The desecration of the grave grew to be a problem, and the bulbs could no longer be planted.

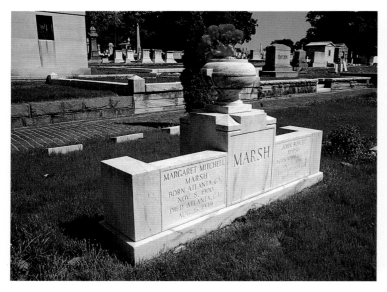

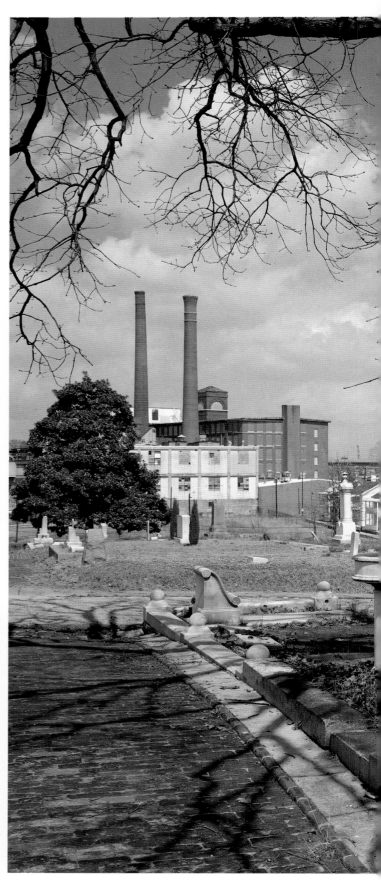

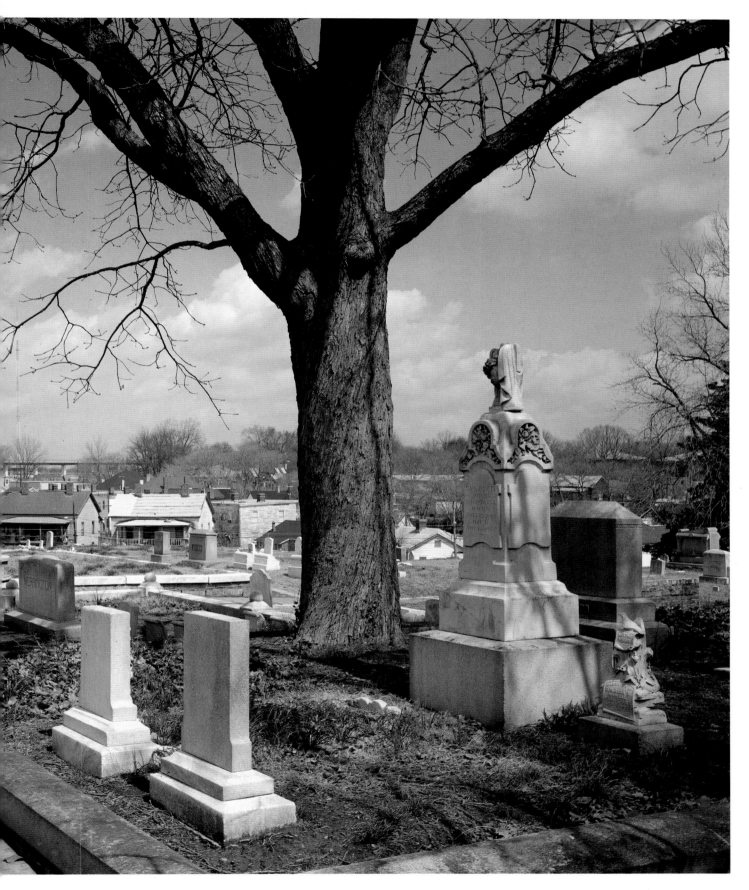

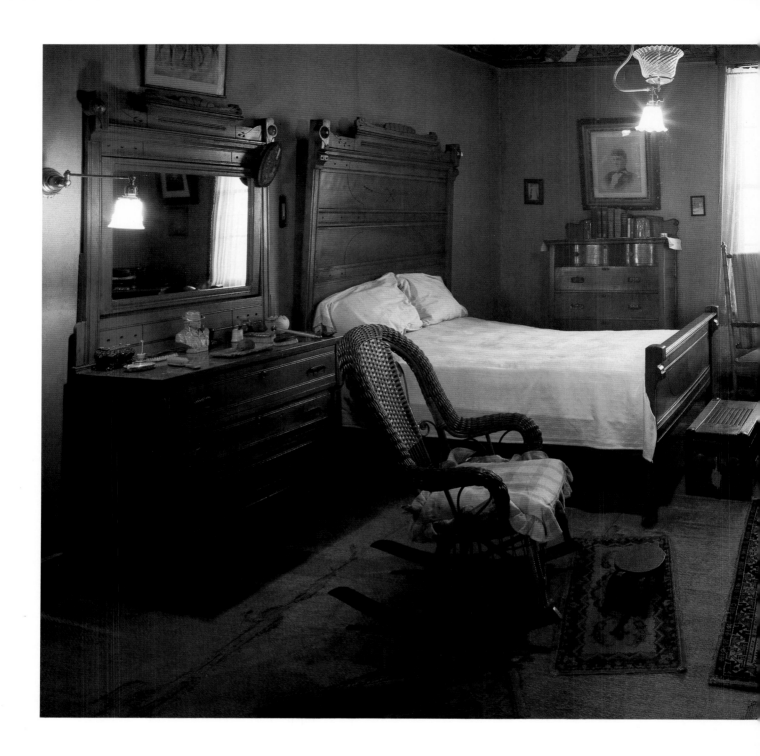

| Wren's Nest, home of author Joel Chandler Harris

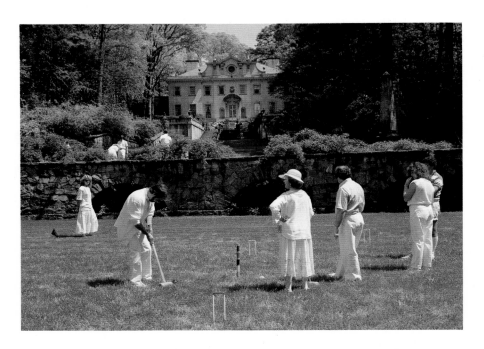

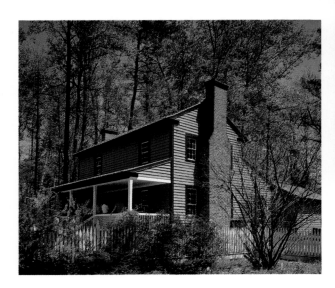

opposite and overleaf: Swan House interiors

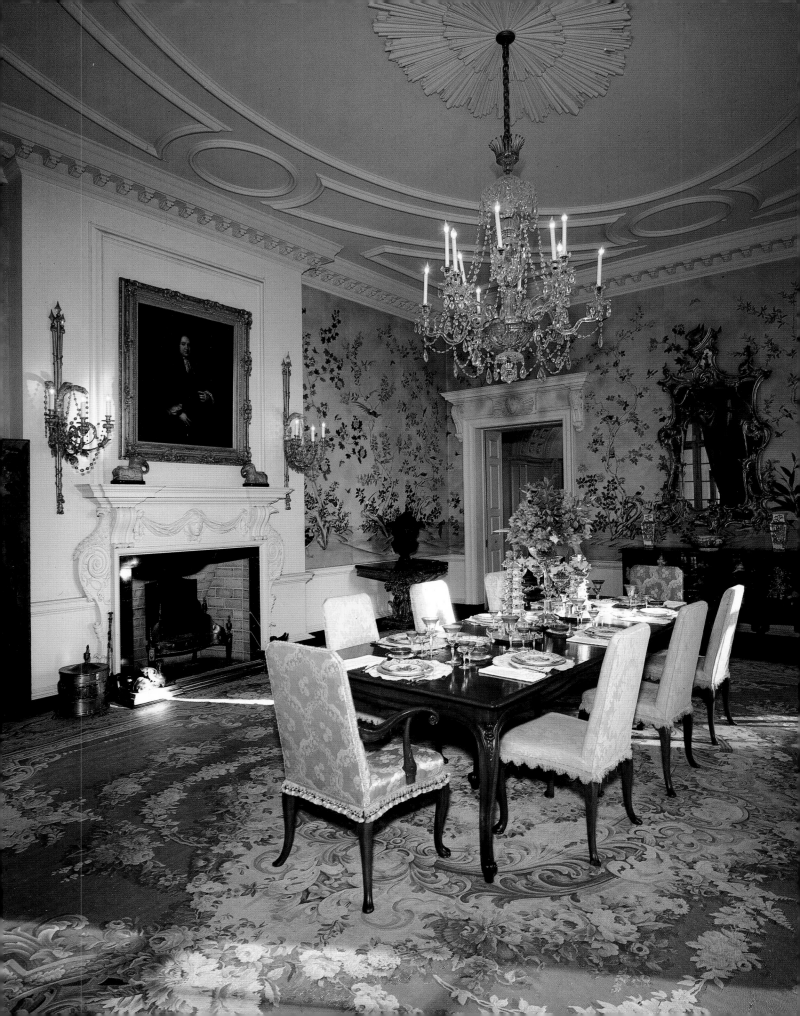

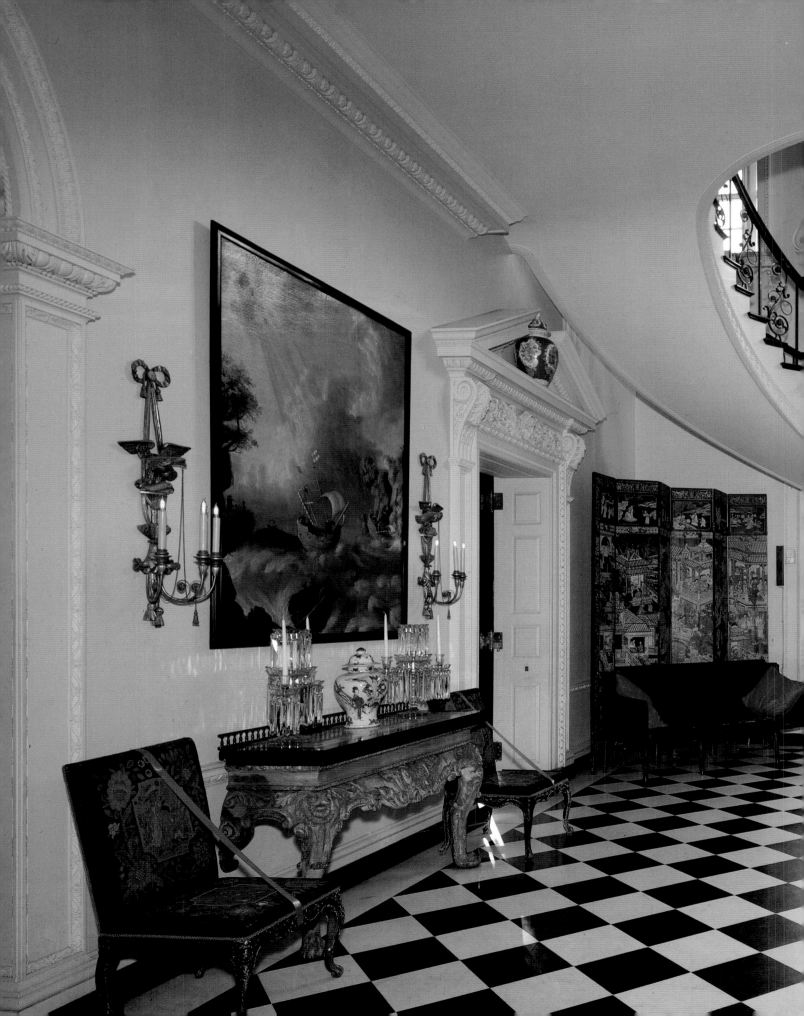

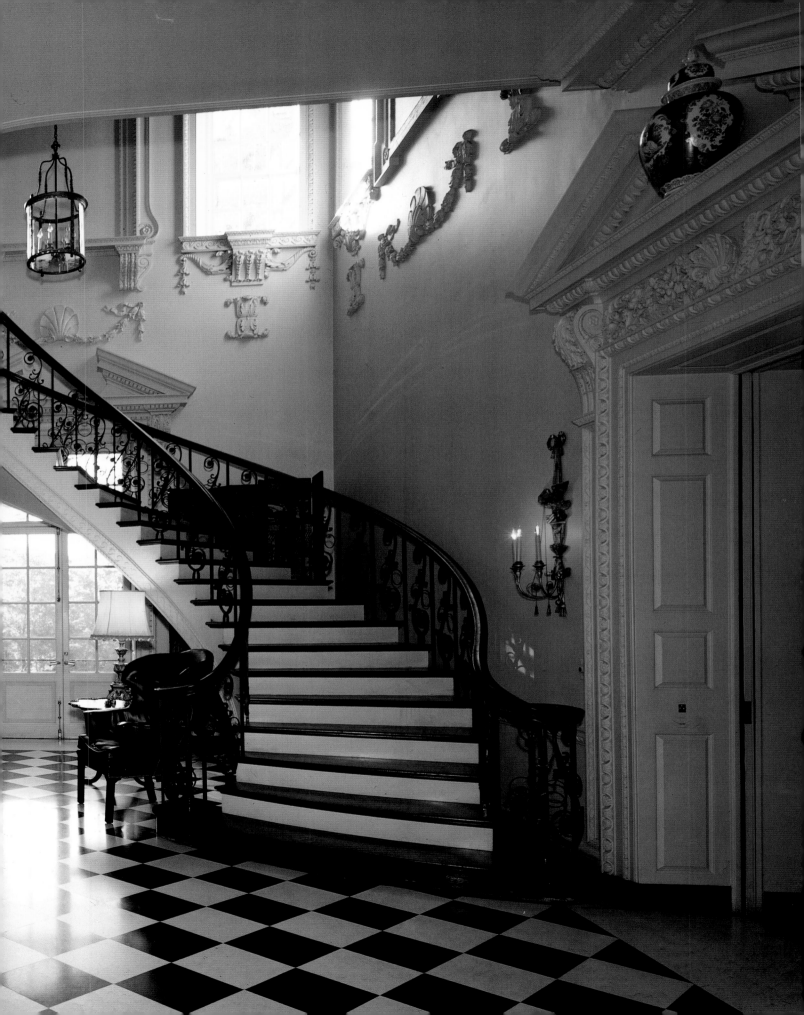

*I*f it were not for Louise Allen, the Atlanta Historical Society might still be meeting in a converted residence on Peachtree Street. Instead, the historical society now operates out of the Atlanta History Center, a complex comprised of the Atlanta History Museum; McElreath Hall, which houses two libraries devoted to local history; and two historic houses: Swan House and Tullie Smith Farm. The buildings are surrounded by thirty-two acres of gardens that provide a living horticultural history of the Atlanta region.

Allen joined the historical society in 1962, before the Atlanta History Center complex was even a dream. Shortly after she joined the board, a 1928 mansion on Andrews Drive called Swan House went up for sale. Allen convinced the board that the histori-

cal society's future lay not in its Peachtree Road location, but with Swan House on a complex not yet constructed. The Atlanta Historical Society acted on Allen's advice and purchased Swan House and its surrounding property. Ever since that important decision, the historical society has grown in size and influence. The Atlanta History Museum, the latest addition to the Atlanta History Center, is dedicated to Allen to show appreciation for her work.

*L*ouise Allen has volunteered for and led Atlanta's most important civic and cultural organizations, including the Georgia Trust for Historical Preservation, of which she was a founding member. Preservation of the beauty, history, and heritage of Atlanta has been Allen's life work, and her efforts have allowed Atlanta to preserve its past while never losing sight of its future.

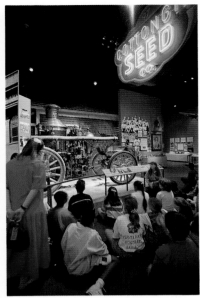

NICHOLSON GALLERY

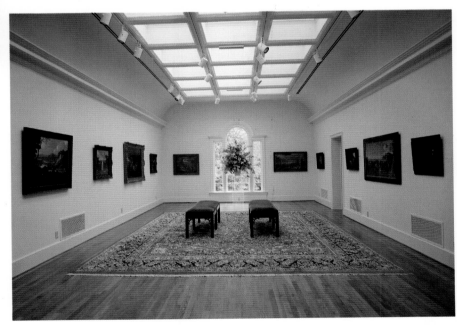

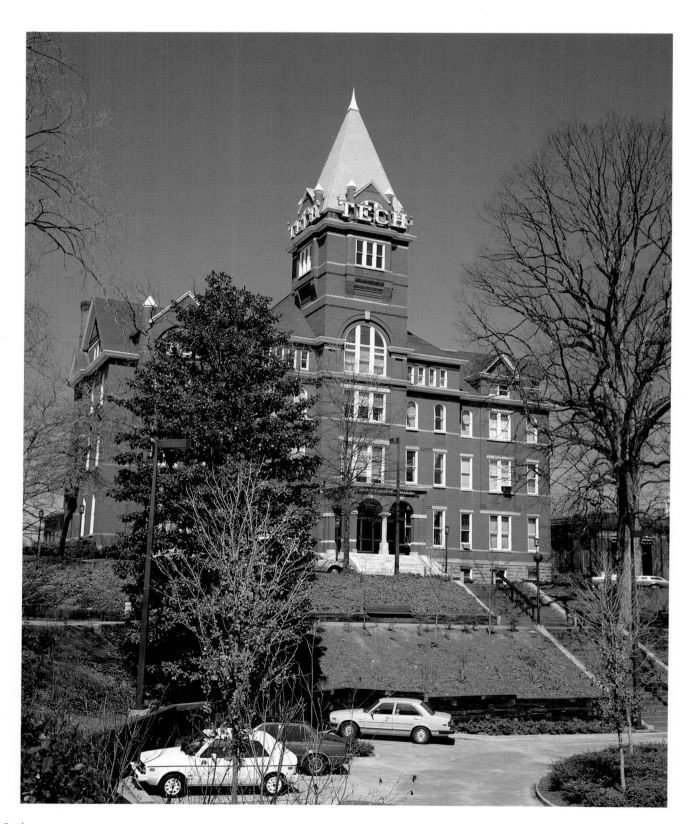

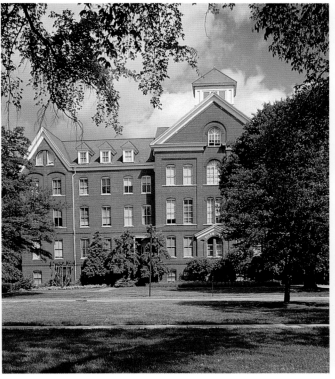

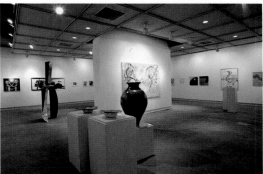

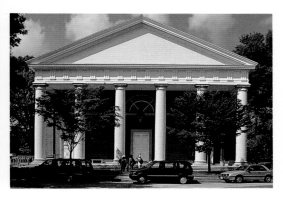

top and center right: Georgia State University
bottom left and right: Spelman College

49

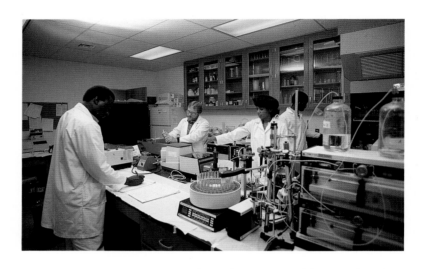

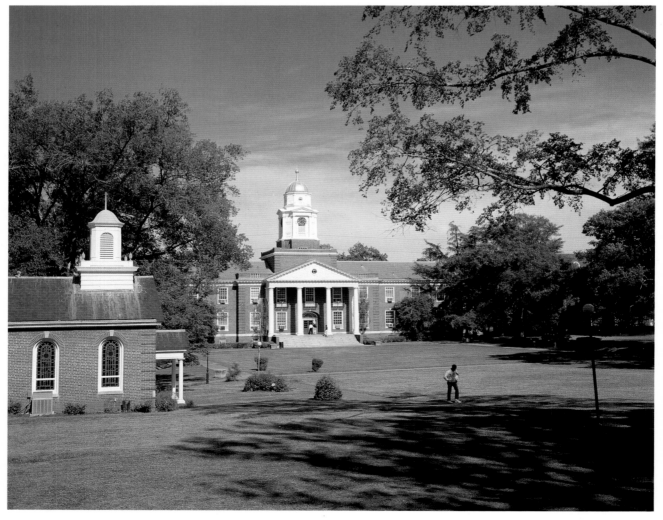

top: Monroe F. Swilley Memorial Library of Mercer University
bottom: Hermance Stadium, Oglethorpe University

Presser Hall, Agnes Scott College

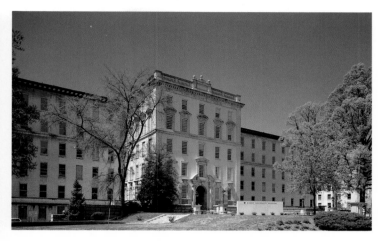

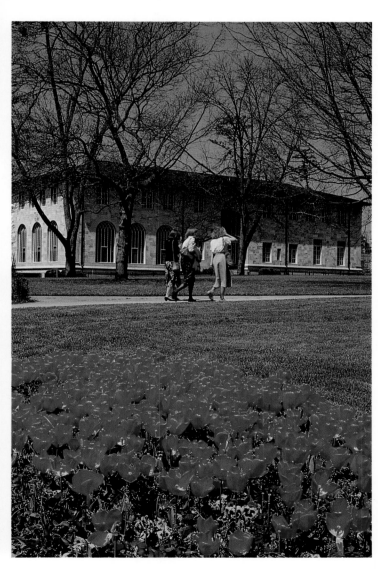

top: Emory University Hospital
bottom: Emory University's Pitts Theological Library, from the Quadrangle
overleaf: Pitts Theological Library of Emory University

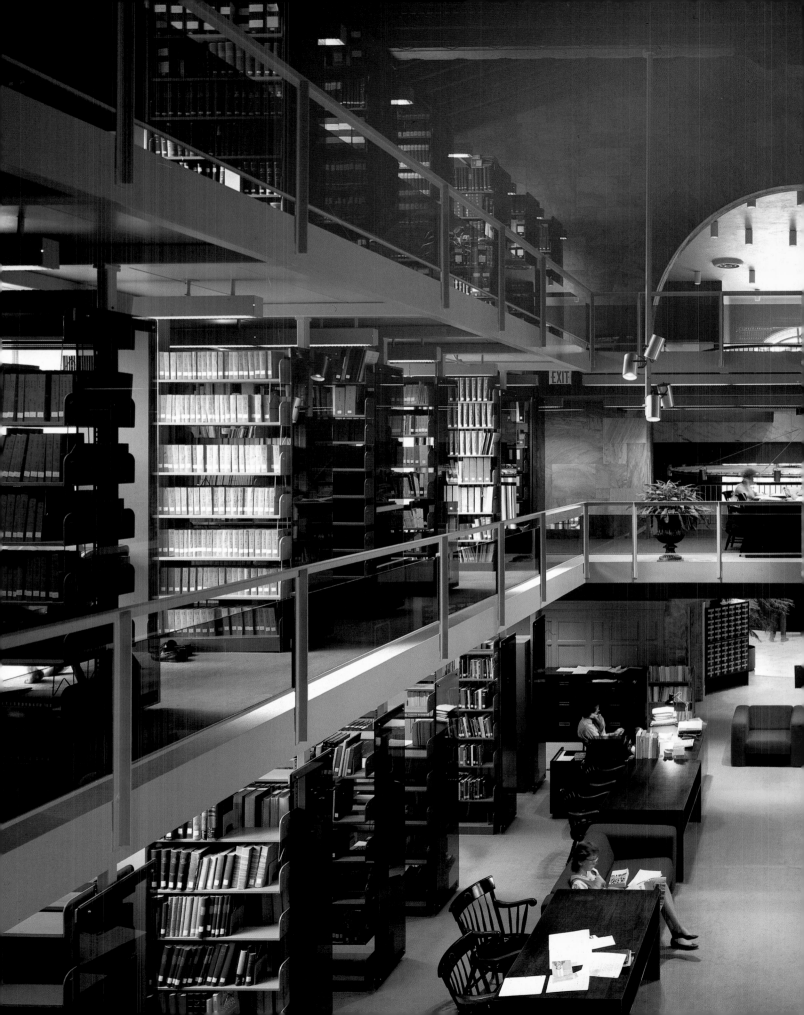

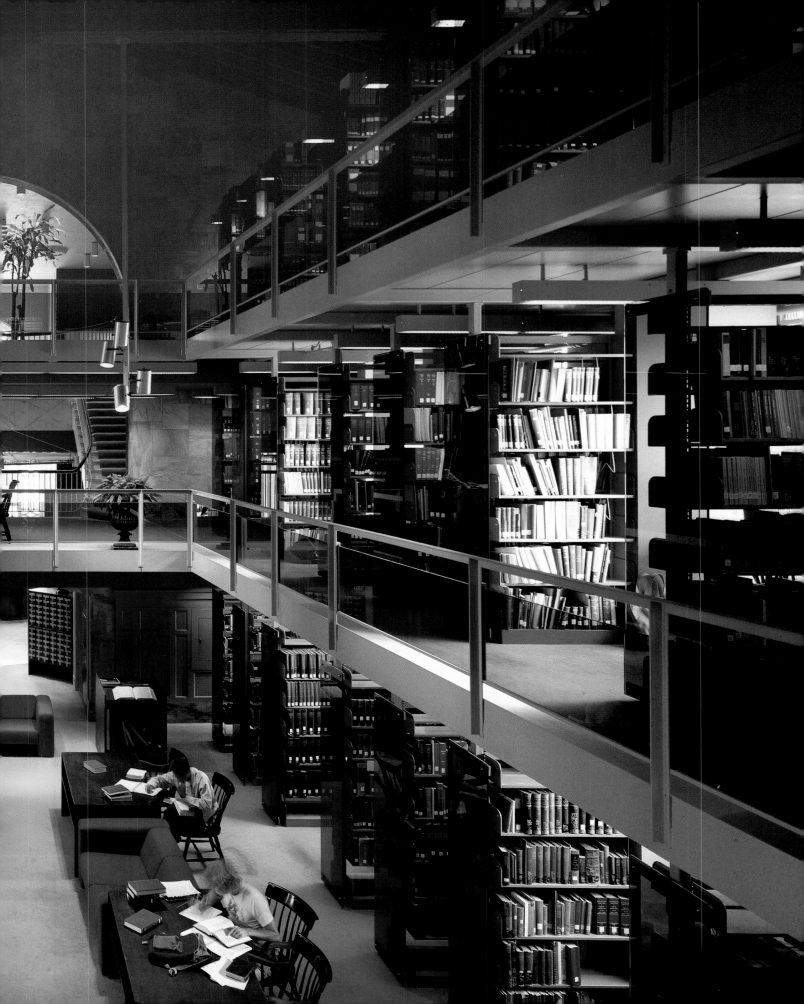

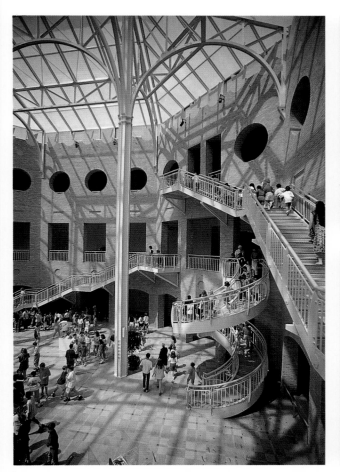

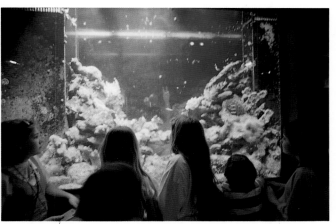

opposite: Planetarium, Fernbank Science Center
top and center: Fernbank Museum of Natural History
bottom: SciTrek

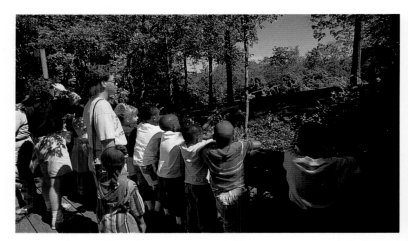

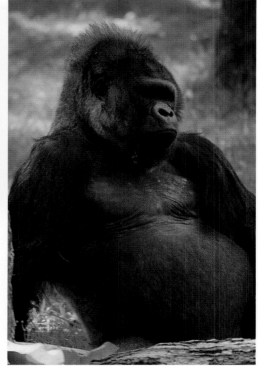

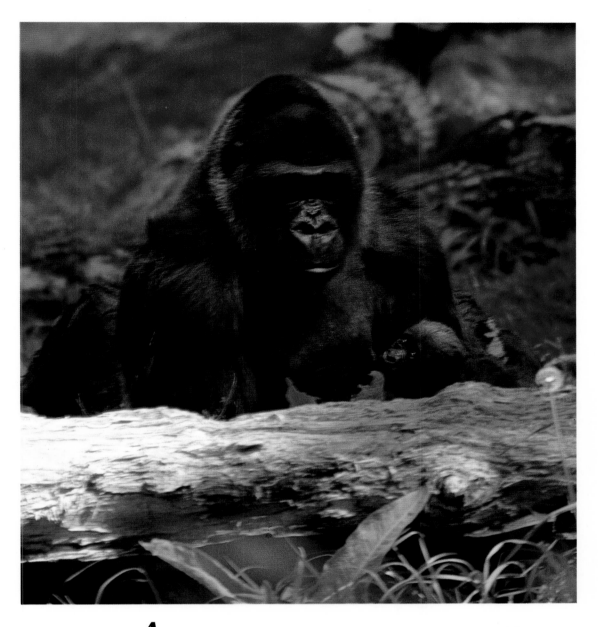

A very special silverback gorilla lives in Zoo Atlanta, a gorilla who has come to symbolize the zoo itself to most Atlantans. Willie B., named after former Atlanta mayor William B. Hartsfield, came to the zoo in 1961 as a two year old who had been captured in the wild. Atlanta watched Willie B. grow up, chipped in with donations to buy a television set for his cage (football became Willie B.'s favorite), and cheered him out from behind his bars and into his new outdoor habitat in 1988. Atlantans also kept their fingers crossed while Willie's keepers tried to encourage a "romantic" relationship between Willie and the female gorillas. Finally, in early 1994, the wait was over; after 34 years of bachelorhood, Willie B. became a father. The children of Atlanta chose the infant female's name, voting for "Kudzu" by an overwhelming margin.

above, Kudzu, with mother Choomba
opposite, top right: Willie B.

top: Sweetwater Creek State Conservation Park
bottom: Six Flags Over Georgia
opposite: Lake Sidney Lanier

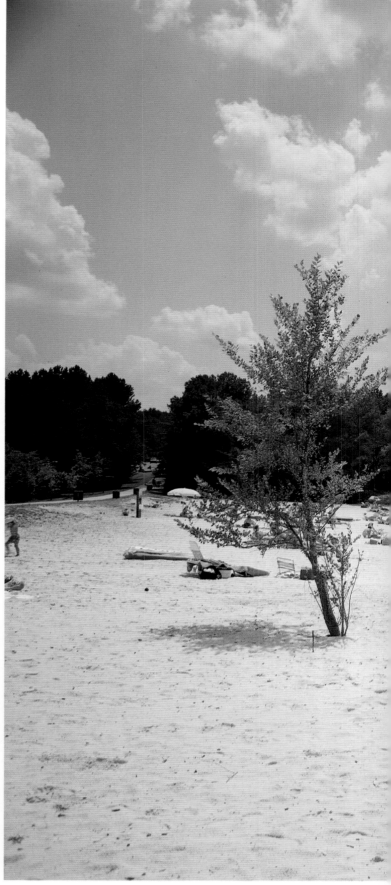

*E*xcursions outside Atlanta offer a variety of recreational activities for Atlantans eager to escape their workday world or for visitors eager to sample the full range of this city's assets. For those who prefer water over land, Lake Sidney Lanier, named after the Georgia poet, lies about an hour's drive north of the city. Boats of every sort sail in the 38,000-acre lake, while the shores are dotted with beaches and swimming areas. Water lovers can also take advantage of the Chattahoochee River, which runs down the length of Georgia; rafting down the river is a popular way to spend a hot summer Saturday.

Those who yearn for solitude and the great outdoors are never far from a hiking trail, even in the heart of downtown Atlanta; numerous state parks maintain trails around Atlanta and throughout north Georgia. Sweetwater Creek State Conservation Park consists of almost 2,000 acres of wilderness, including a 215-acre lake. Georgia's Stone Mountain Park combines history with a wide range of activities, including a skylift to the top of the mountain. If thrills and entertainment are the recreation of choice, Six Flags Over Georgia theme park is only twelve miles west of Atlanta and offers a varied assortment of roller coasters, water rides, and shows. All in all, the wide range of recreational areas existing around Atlanta leaves no excuse for anyone to be bored, inside or outside the city.

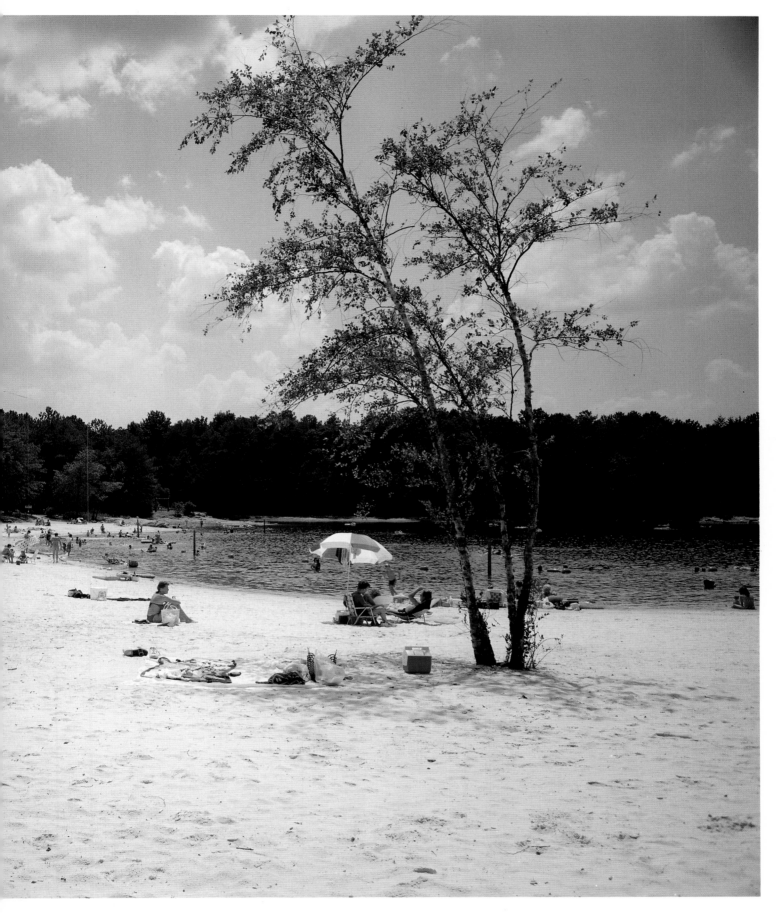

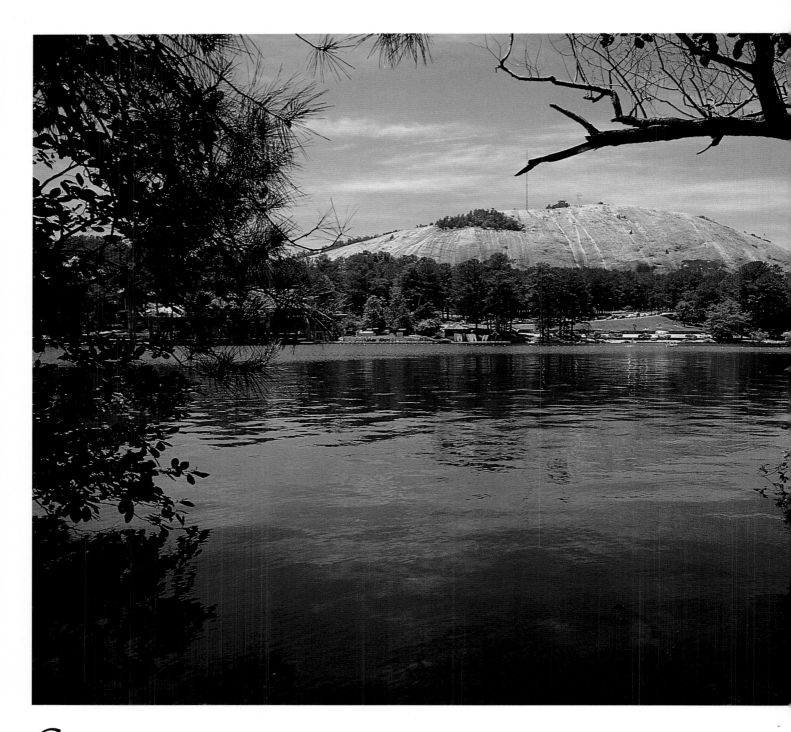

Georgia's Stone Mountain Park is home to both the world's largest outcropping of granite and the world's largest bas-relief sculpture, the 90-by-190-foot Confederate Memorial Carving. This carving, which portrays Confederate President Jefferson Davis, General Robert E. Lee, and General Thomas "Stonewall" Jackson all on horseback, emerges from the steep north face of Stone Mountain and solemnly looms over the park. One of the famous stories about this carving tells of two luncheons held to honor those involved in the creation of the carving. Both the 1924 and the 1970 luncheons were carried out with pomp and circumstance, including a full dining-room setting with wait staff. The remarkable thing about these banquets was their location—both were held on the shoulder of Robert E. Lee's image.

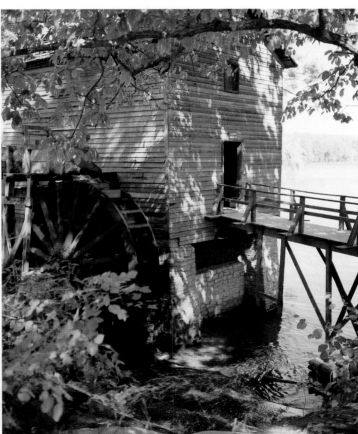

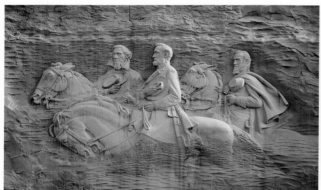

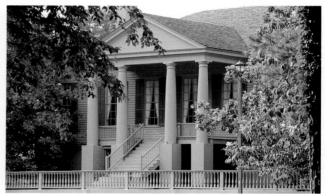

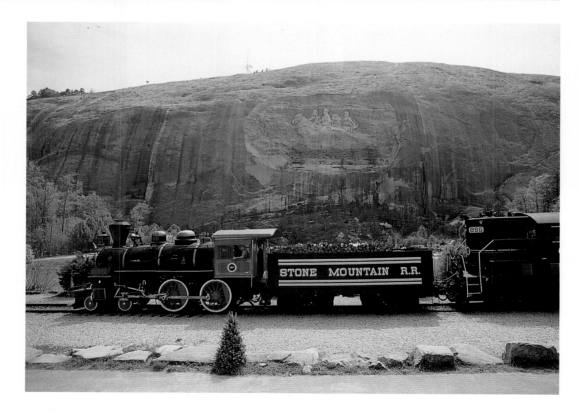

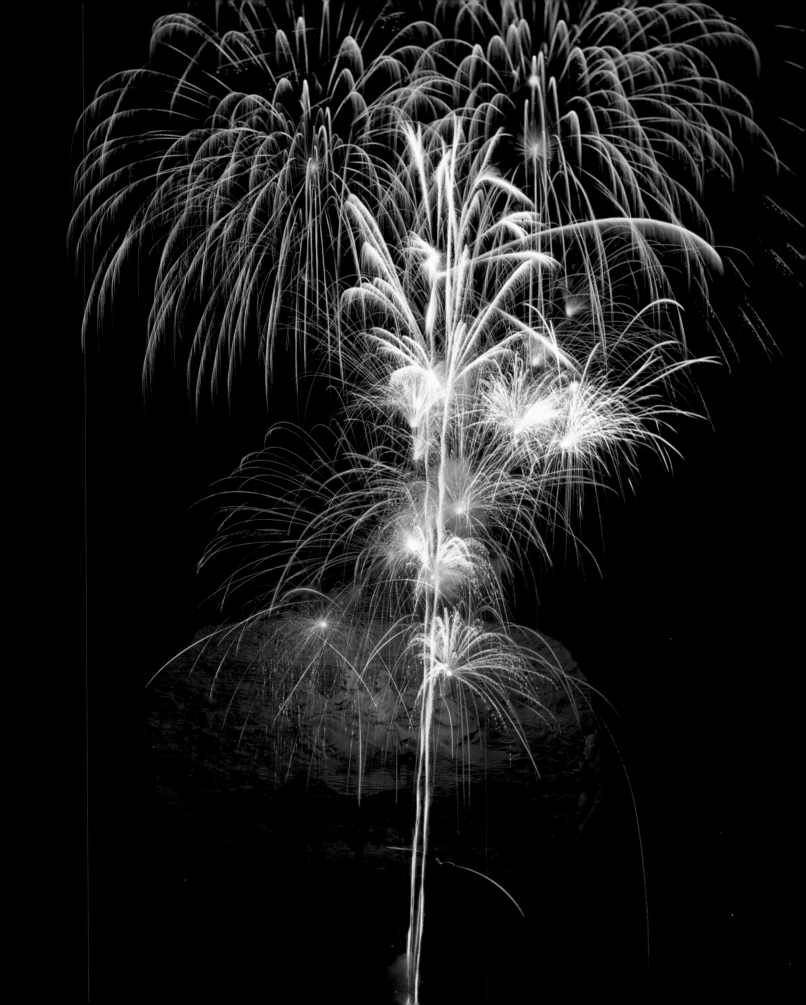

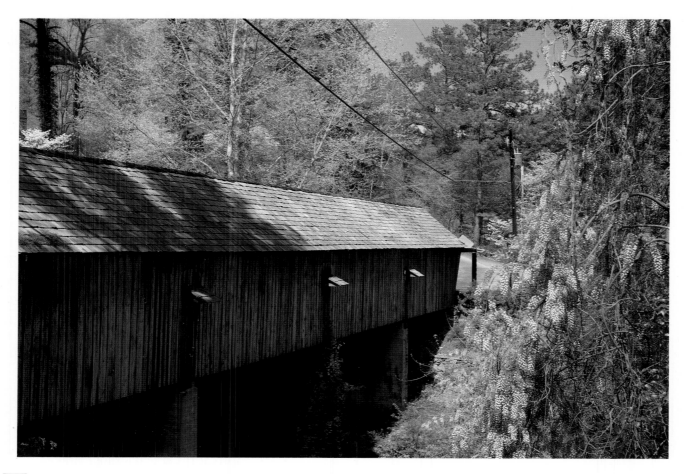

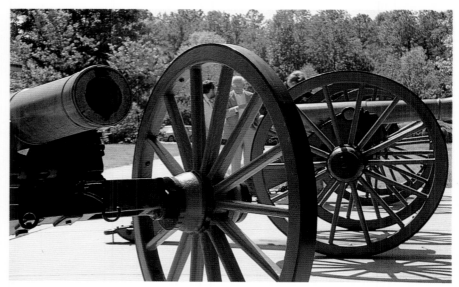

*T*he roots of Peachtree Street reach back to the point at which Cherokee and Creek Native American tribes forded the Chattahoochee River. White settlers knew the ford as Standing Peachtree, named after a large tree that served as a landmark for the shallow crossing point.

History turns into debate at this point—pragmatists maintain that the famous tree must have been a "pitch" tree, what we would call today a pine, since peach trees are not indigenous to Georgia. Romantics don't think the settlers could have been so mistaken in their horticulture; they believe that a peach tree did flourish beside the Chattahoochee, brought there by happy accident from the orchards of the coast.

In any case, the name "peachtree," became synonymous with this new territory. The first fort in the area was called Fort Peachtree, and the road that connected Fort Peachtree with its closest neighboring fort was called Peachtree Road. From that point on, the peach tree was destined to be part of this area's future; in modern Atlanta, more than fifty streets, roads, circles, and drives have the word "peachtree" somewhere in their name.

top: Concord Bridge
bottom: Kennesaw Mountain National Battlefield Park

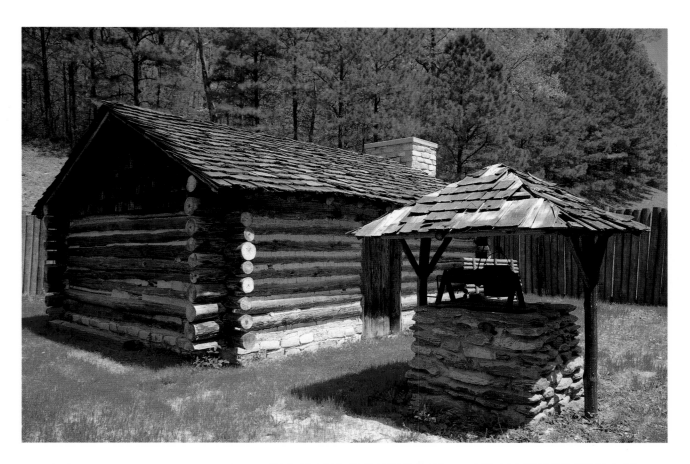

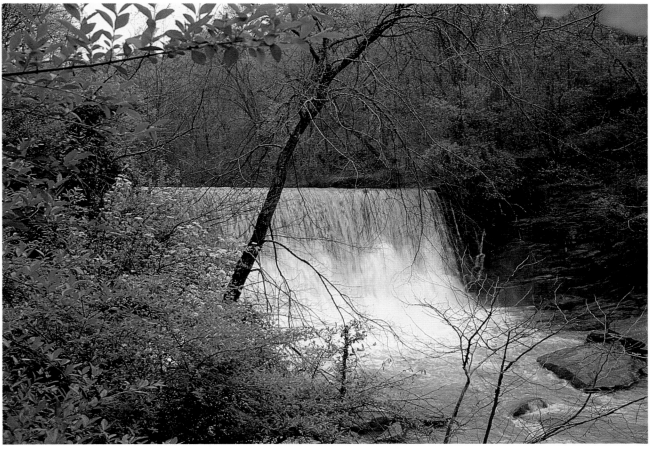

top: Fort Peachtree
bottom: Vickery Creek Dam

69

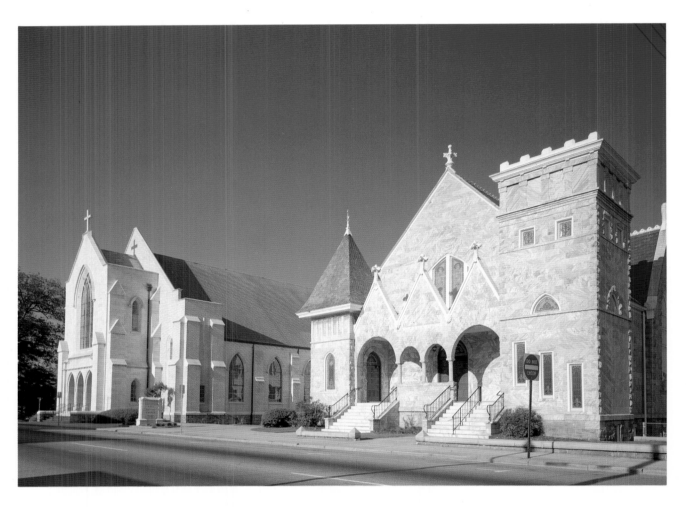

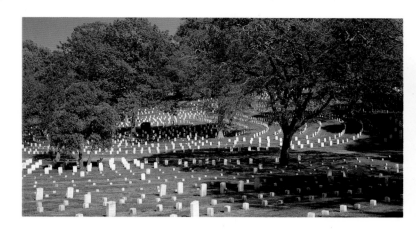

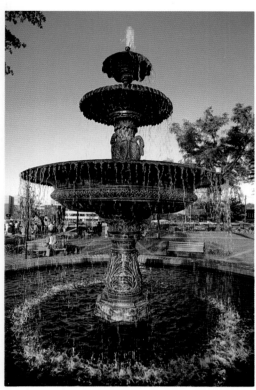

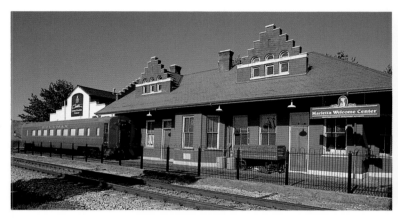

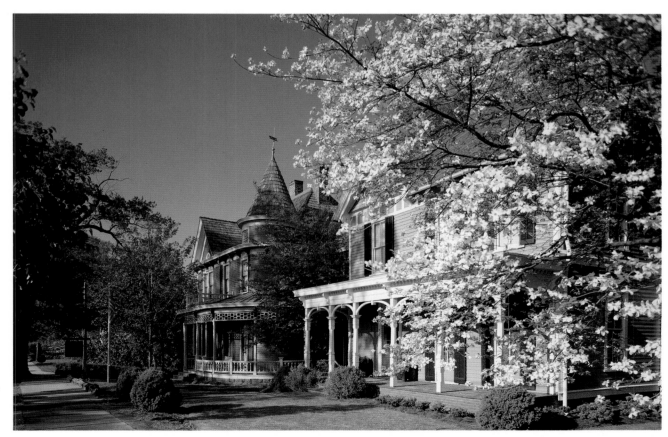

During the Civil War, Northern troops forded the Chattahoochee and moved on Roswell. The desperate mill superintendent of the Roswell Manufacturing Company flew a French flag over the complex in an attempt to claim neutrality and avoid the Union torches. General Sherman, who knew the mill was a major supplier of cloth goods to the Confederate South, was enraged by this attempt at subterfuge and ordered that the town of Roswell suffer an unusual punishment. The Union troops razed the buildings and then forced the majority of the mill workers—men, women and children—to travel by foot or wagon to Marietta and then to Nashville by rail. Sherman's orders stipulated that the displaced Roswellians would then be shipped by rail to Indiana for forced resettlement. But history simply loses track of the deportees beyond their Nashville stop, and the mystery of their disappearance remains unsolved today.

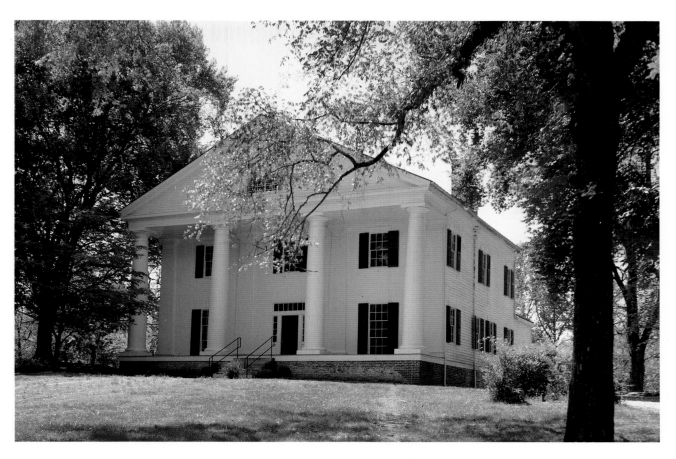

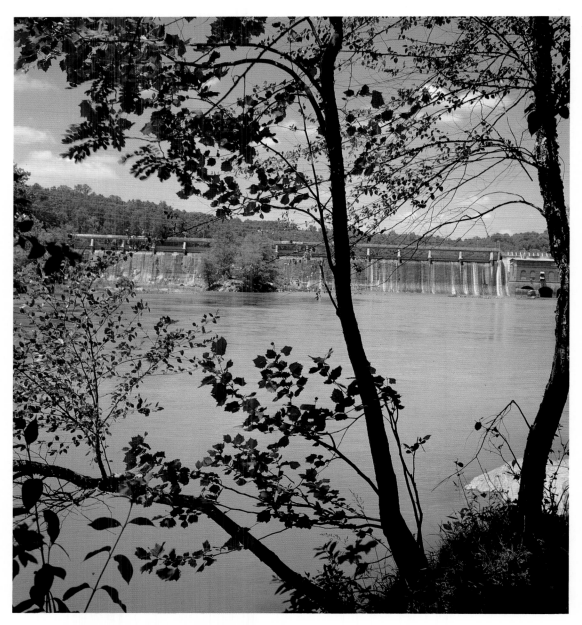

*T*he Chattahoochee River, one of the major rivers of America, slices through the state of Georgia on its journey south. The river's unusual name, which means "The River of the Painted Rocks," comes from the Cherokee Native Americans who first travelled its path. Each summer, the Chattahoochee, known as "The Hooch" to locals, hosts thousands of rafters, fishermen, canoeists, and picnickers in the Chattahoochee River National Recreational Area, a national park which includes 4,100 acres of parkland and seventy miles of hiking trails.

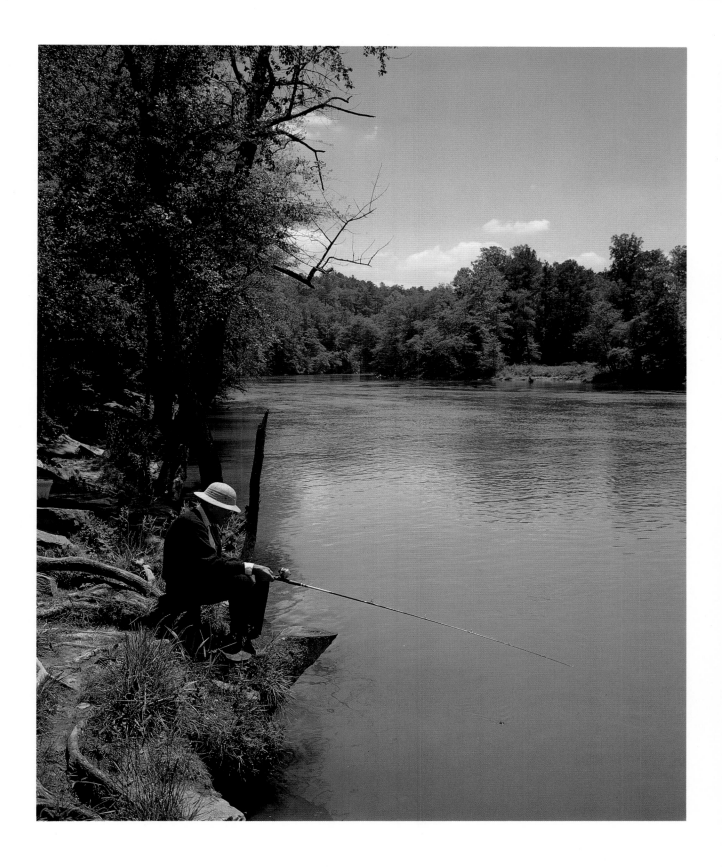

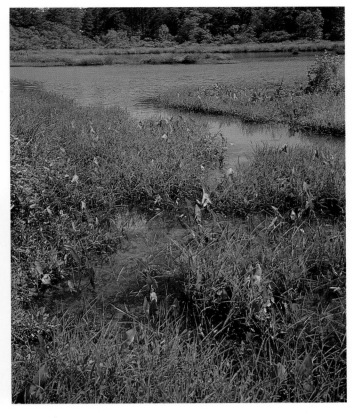

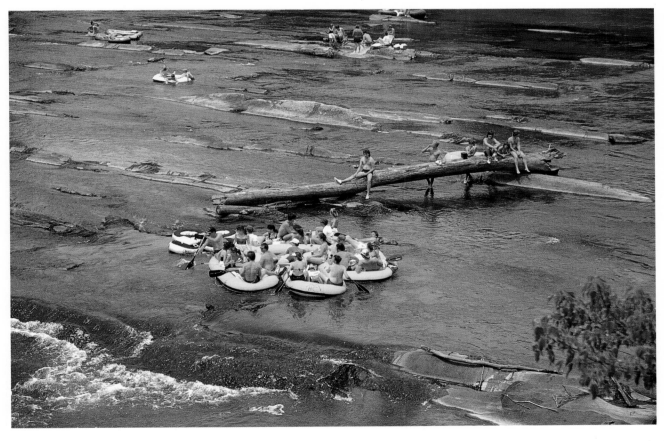

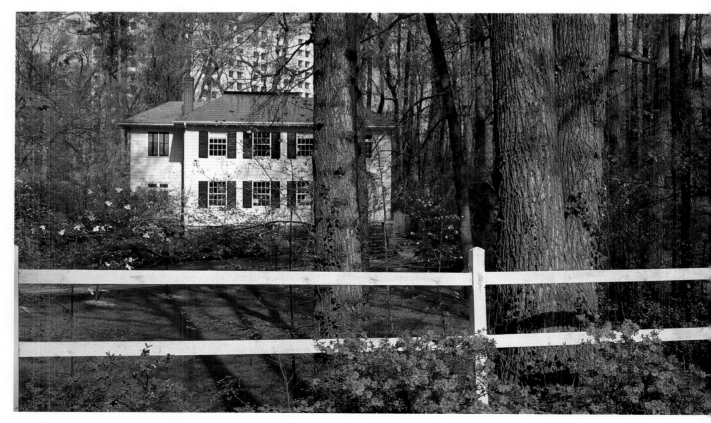

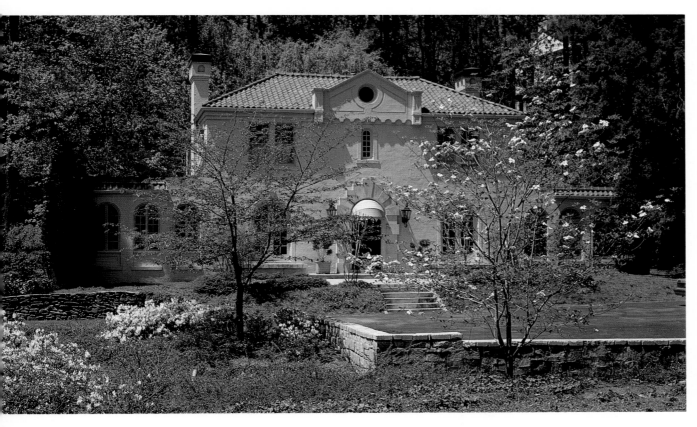

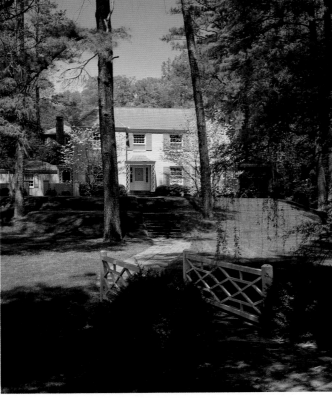

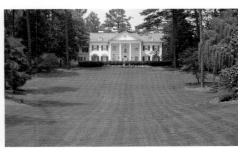

overleaf: a garden in Buckhead | 79

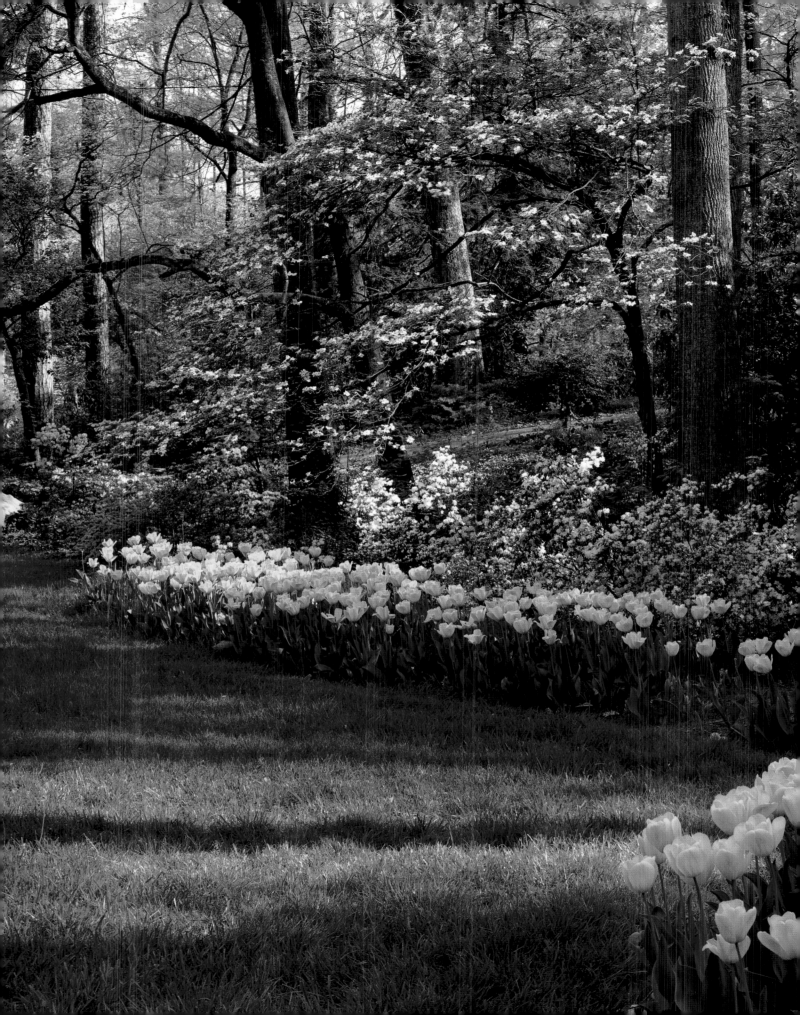

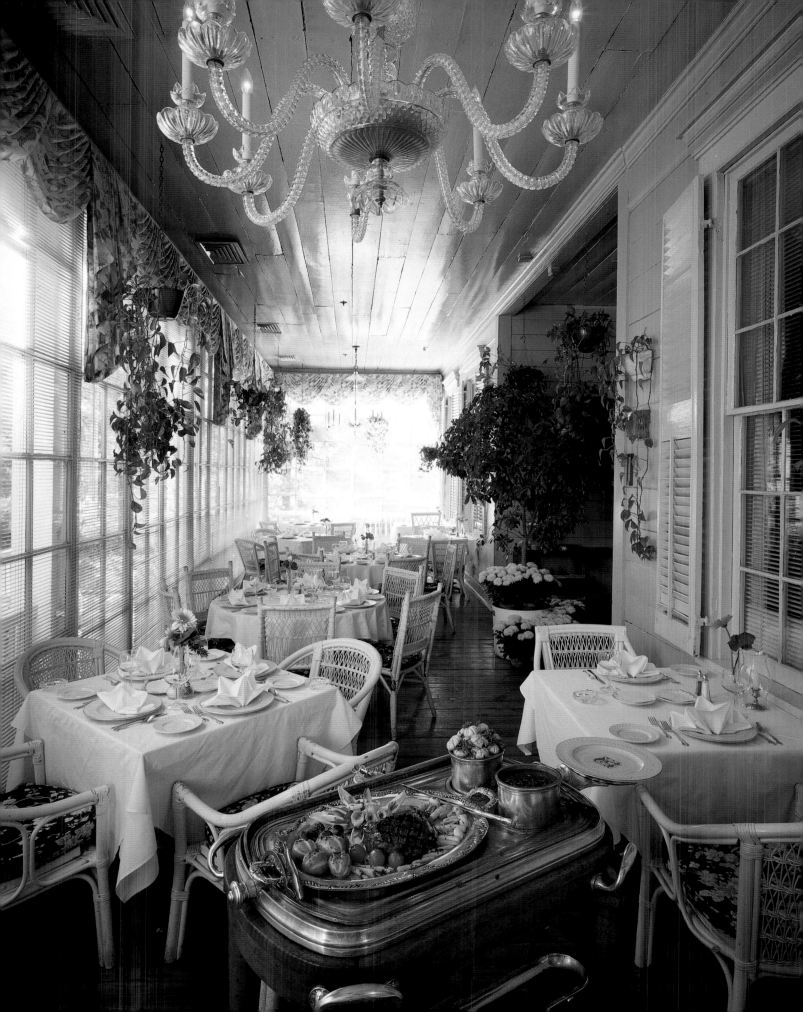

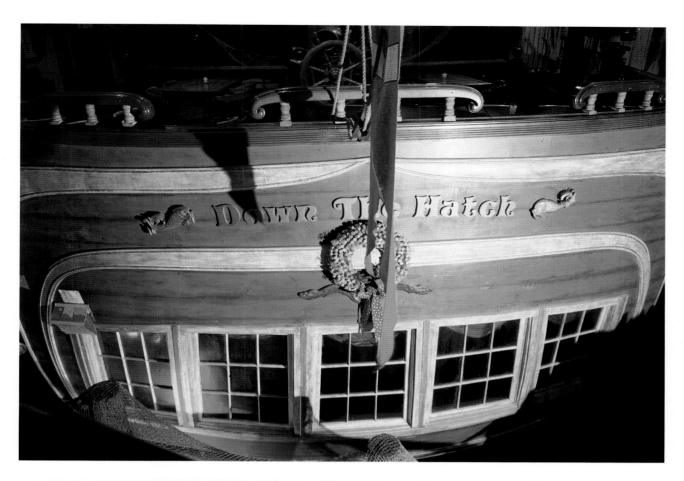

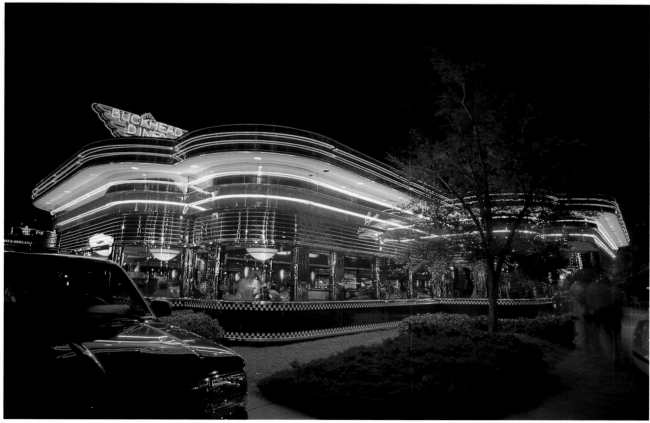

Three famous Buckhead restaurants |

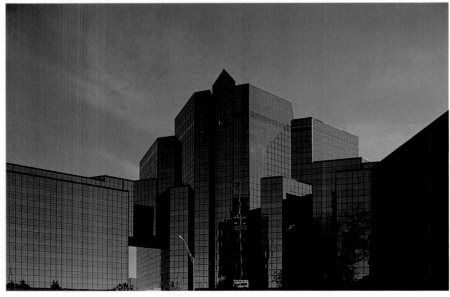

84 *top:* Peachtree Street, south from Lenox Square
bottom: Buckhead's Atlanta Financial Center

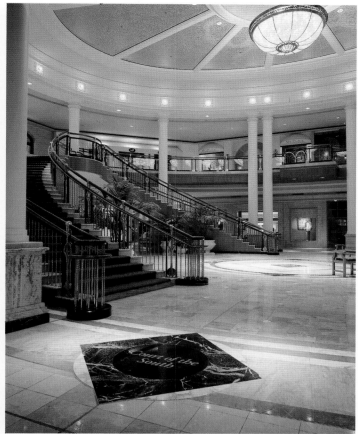

*I*n 1838, Henry Irby invested in the future of Atlanta when he bought a little over 200 acres of land near Peachtree Road. He decided to build a combination tavern and retail grocery on a portion of his new property. Not long after Irby established his business, someone, maybe even Irby himself, shot and killed a large male deer at a spring just a few hundred feet away from Peachtree Road. Proud of his accomplishment, the hunter mounted the head of the buck on a post at the site of the kill. The area surrounding the spring, including Irby's tavern, soon became synonymous with the famous buck's head. And so Buckhead, a center of modern-day Atlanta's night life, acquired its unusual name—and its first bar.

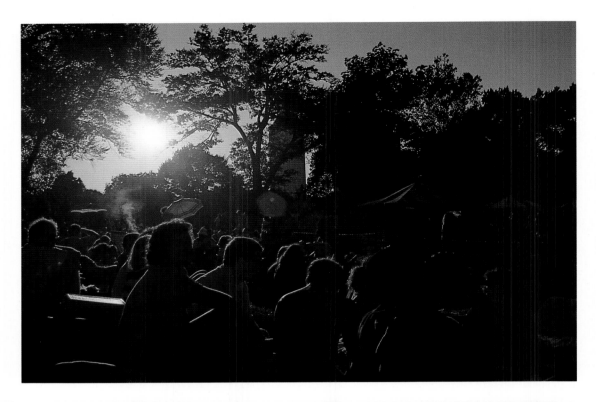

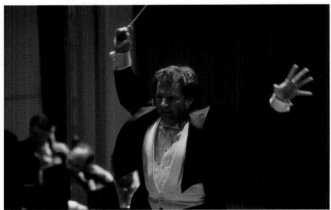

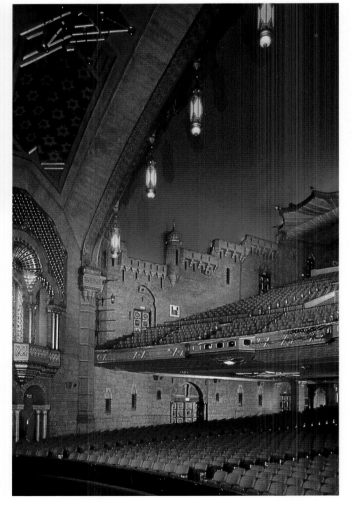

top: Piedmont Park Jazz Festival
bottom left: Yoel Levi and the Atlanta Symphony Orchestra
bottom right: Fox Theater

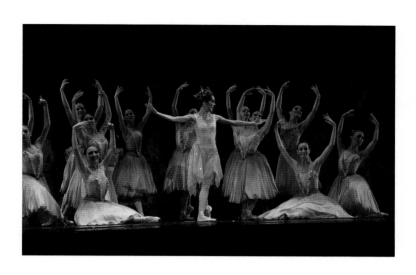

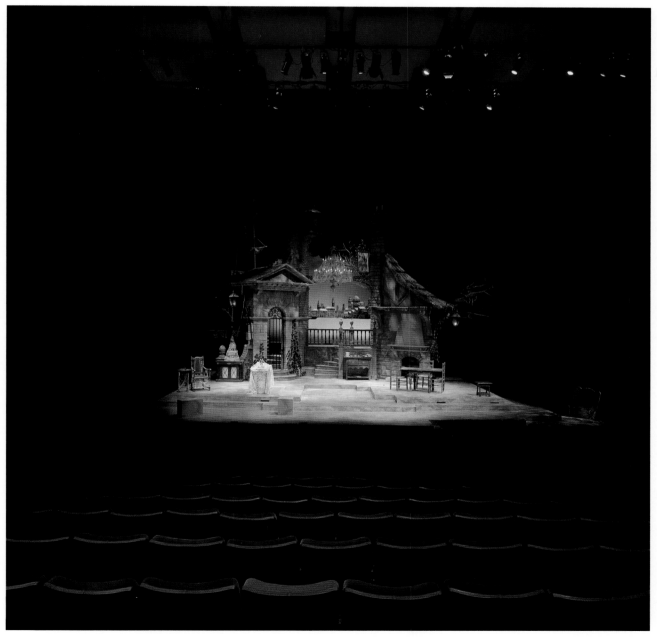

When Amos G. Rhodes arrived in Atlanta in 1875, his pockets held only a gold watch and seventy-five dollars. By the turn of the century, the onetime carpet tacker owned one of the country's largest chains of furniture stores and had become a business leader in the community. Rhodes began construction on a new house for himself and his family in 1902; Rhodes Hall, with its eclectic architecture and elaborate Victorian interior, was completed in 1904.

Two of the most spectacular aspects of Rhodes Hall are the carved mahogany staircase and the stained glass window series that dominates the stairway. The series, now named "The Rise and Fall of the Confederacy," was installed in 1905, a year after the house was completed. Nine panels portray four distinct scenes: the inauguration of Jefferson Davis as president of the Confederate states, the beginning of the Civil War with the firing on Fort Sumter, Thomas "Stonewall" Jackson at Manassas, and Robert E. Lee at Appomattox. Fifteen Confederate generals and statesmen are also pictured, as well as the seals of the thirteen Confederate states.

Atlanta began its cycle of destruction and reconstruction at the end of the Civil War. What was an incredibly successful response to near total annihilation did not work quite as well in the years that followed; Atlanta began to lose all vestiges of its past in its rush to replace the old with the new. Within the last decade, this tendency has been replaced with a new emphasis on preservation. In fact, Rhodes Hall now serves as the headquarters for the Georgia Trust for Historic Preservation and is open to the public as a museum. This house is a wonderful example of restoration at its finest, as are the Fox Theater and the Georgian Terrace Apartments; all are buildings of great historical value and beauty that have been saved for future generations to learn from and enjoy.

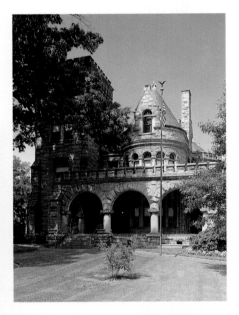

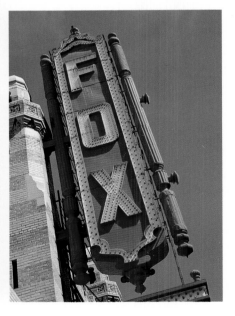

left: Georgian Terrace Apartments
center right: Rhodes Hall
bottom right: Fox Theater
opposite: Rhodes Hall's ornate staircase

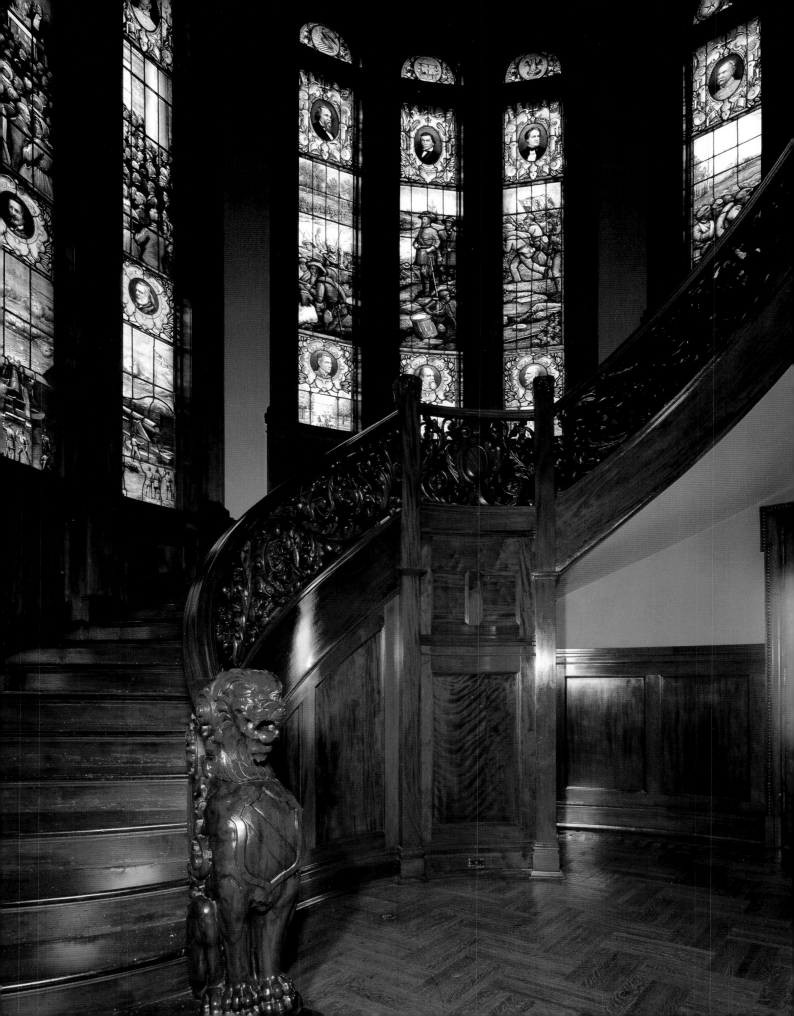

Very rarely does one man's vision become a global reality, but William "Billy" Payne's dream to bring the Olympics to Atlanta was realized in front of the entire world. Spearheaded by Payne's efforts, Atlanta overcame tremendous odds to become the International Olympic Committee's choice as host city for the 100th anniversary of the Olympic Summer Games.

In 1987, Payne led a campaign to fund a new sanctuary in St. Luke's Presbyterian Church. As Payne sat in the new sanctuary, his sense of satisfaction with that accomplishment inspired him to consider another campaign—bringing the Olympics to Atlanta. Payne's colossal efforts to make others believe in his dream began that same day.

One of Payne's first converts was Mayor Andrew Young, whose initial doubts were overcome by Payne's enthusiasm and vision. Mayor Young's support added international stature to Payne's

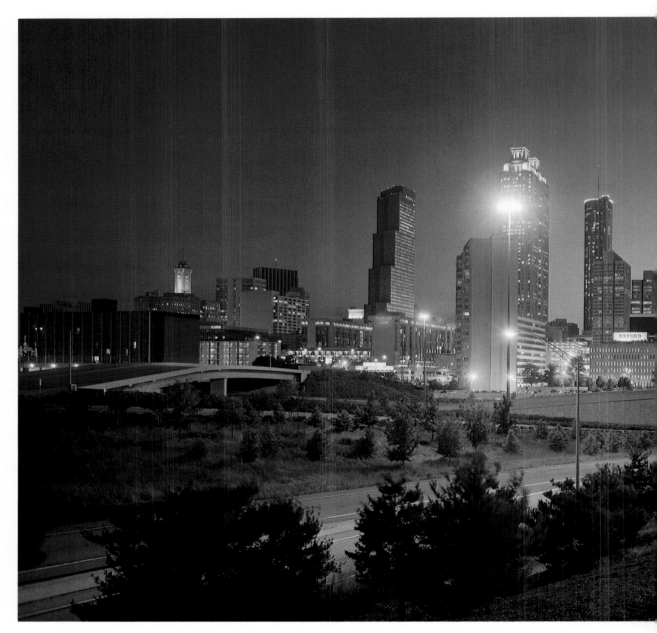

efforts, moving the Atlanta Olympics beyond the realm of one man's dream. Payne's plan to win the support of the Olympic Committee was simple—know the voters and make sure the voters knew Atlanta. He took his enthusiasm and belief in Atlanta directly to the committee members, traveling around the world, building friendships, and escorting international visitors around the city. On September 18, 1990, Payne's dream, which had also become Atlanta's dream, came true—Atlanta was chosen as the site of the 1996 Olympic Summer Games.

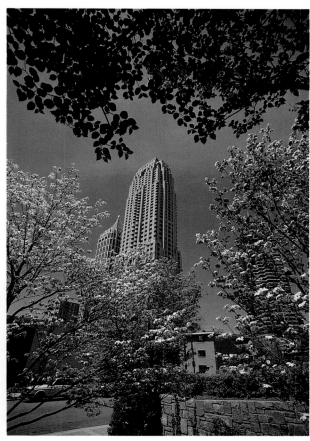

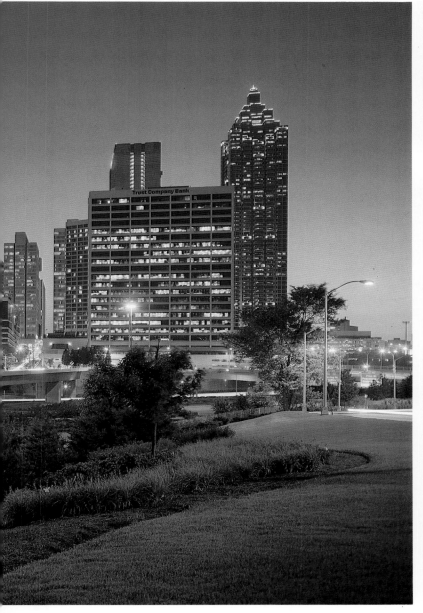

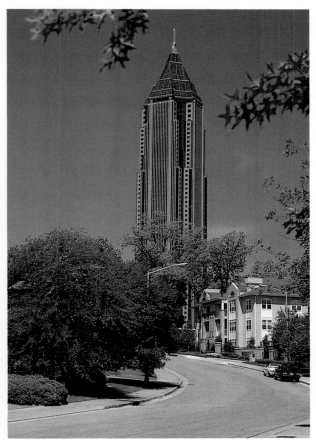

left: downtown skyline
top right: Occidental Grand Hotel
bottom right: NationsBank building

91

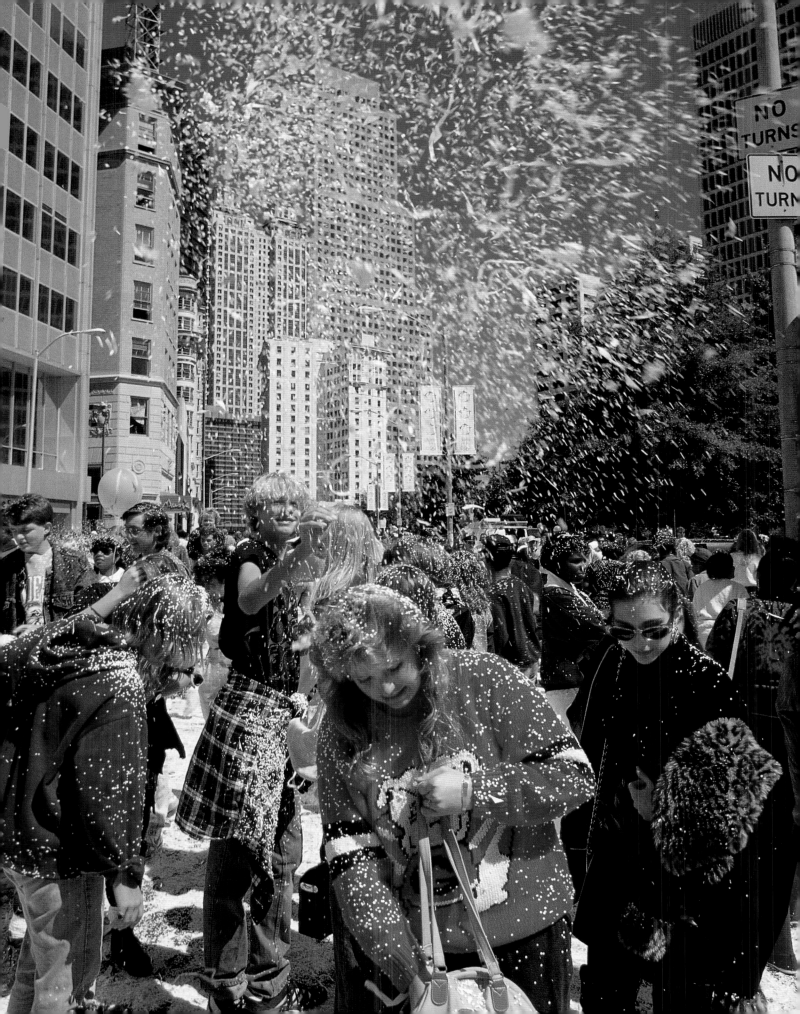

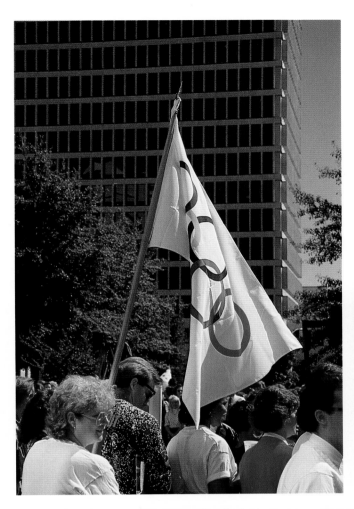

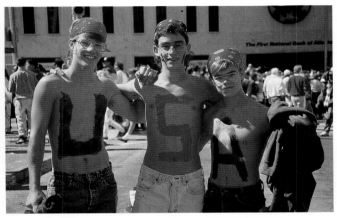

celebrating Atlanta's winning bid for the 1996
Olympic Summer Games

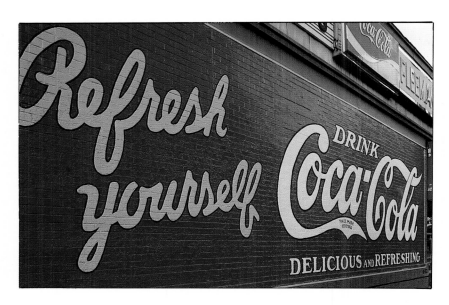

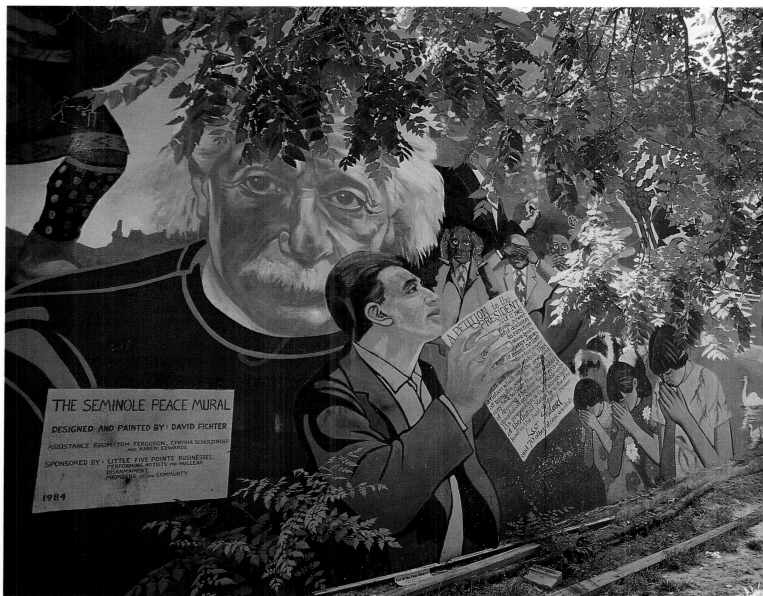

THE SEMINOLE PEACE MURAL

DESIGNED AND PAINTED BY: DAVID FICHTER

ASSISTANCE FROM: TOM FERGUSON, CYNTHIA SCHERZINGER AND KAREN EDWARDS

SPONSORED BY: LITTLE FIVE POINTS BUSINESSES, PERFORMING ARTISTS FOR NUCLEAR DISARMAMENT, MEMBERS OF THE COMMUNITY

1984

top: vintage Coca-Cola sign, Virginia-Highland
bottom: Seminole Peace Mural, Little Five Points

top: outdoor dining, midtown
bottom: world-famous Varsity drive-in

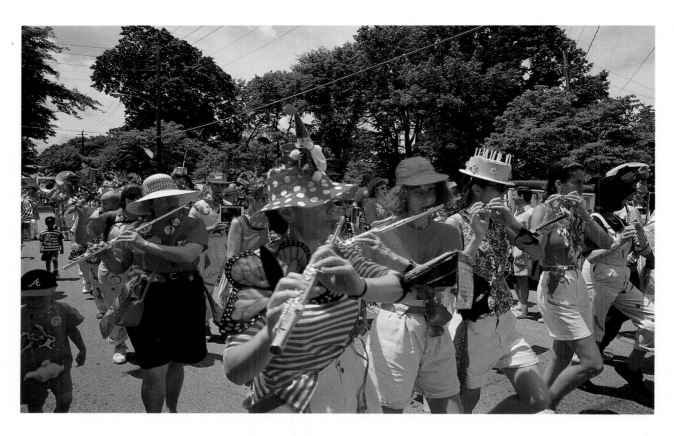

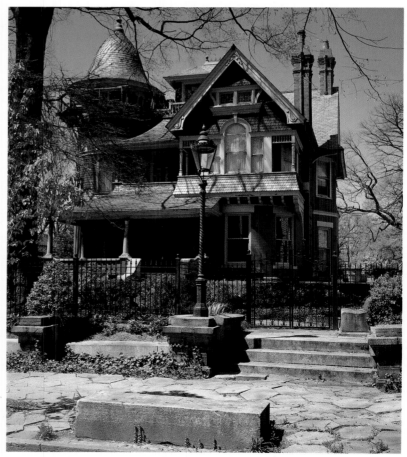

| Inman Park, an intown Atlanta neighborhood

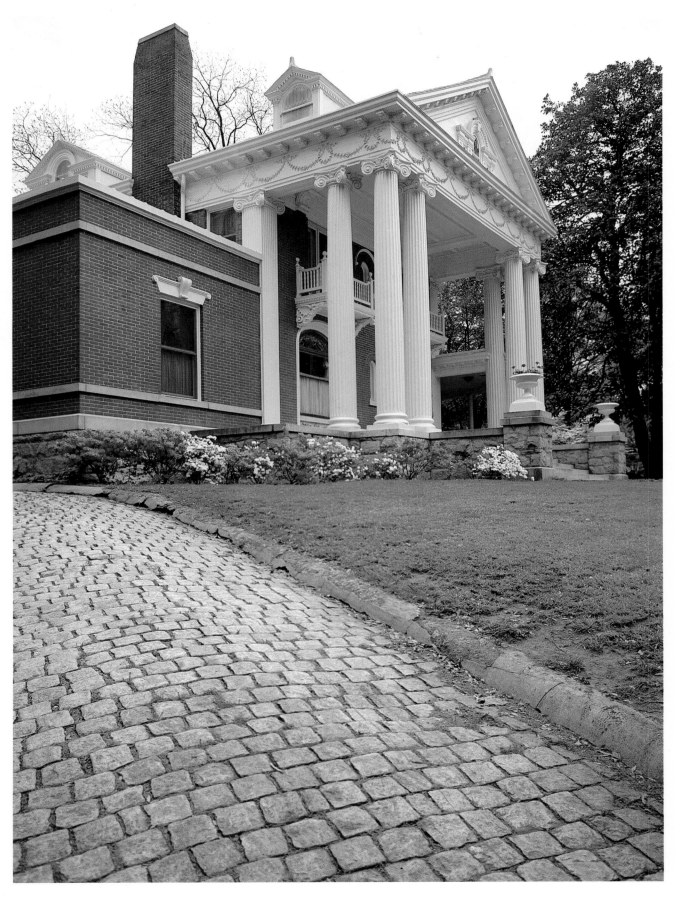

Callan Castle, Inman Park

overleaf: garden of Ryan Gainey, Decatur

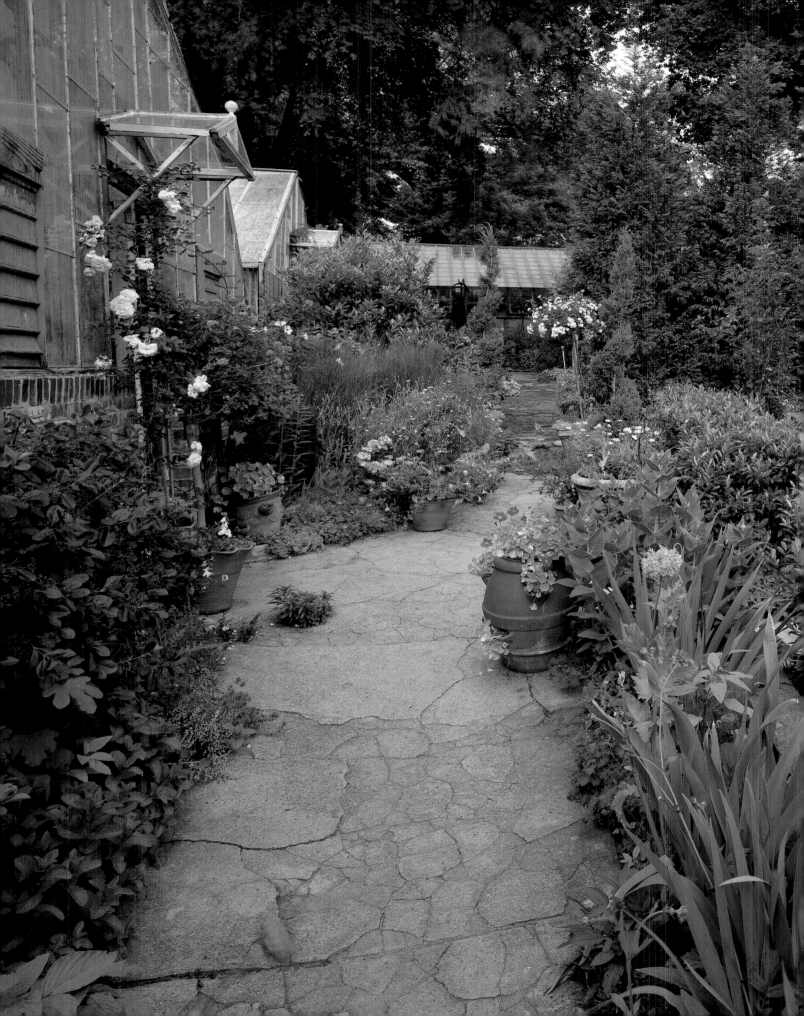

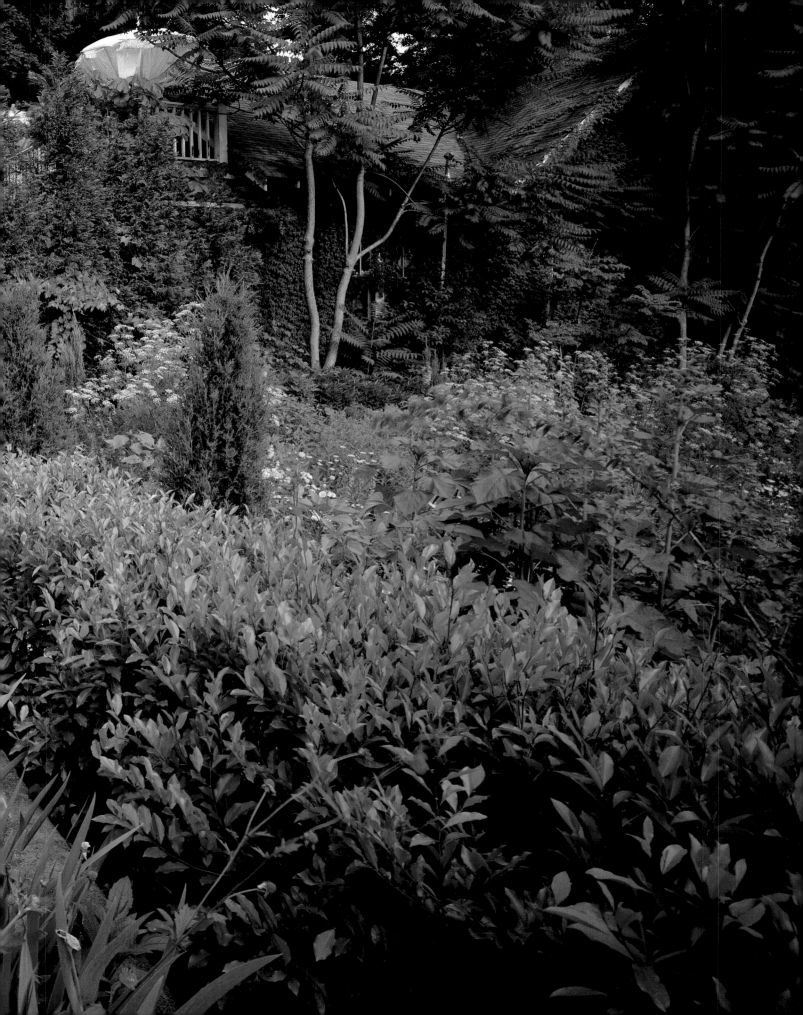

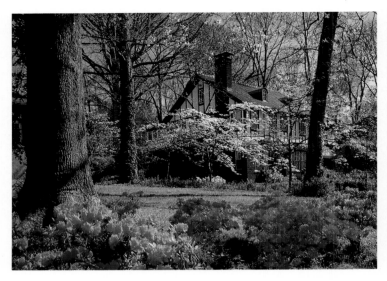

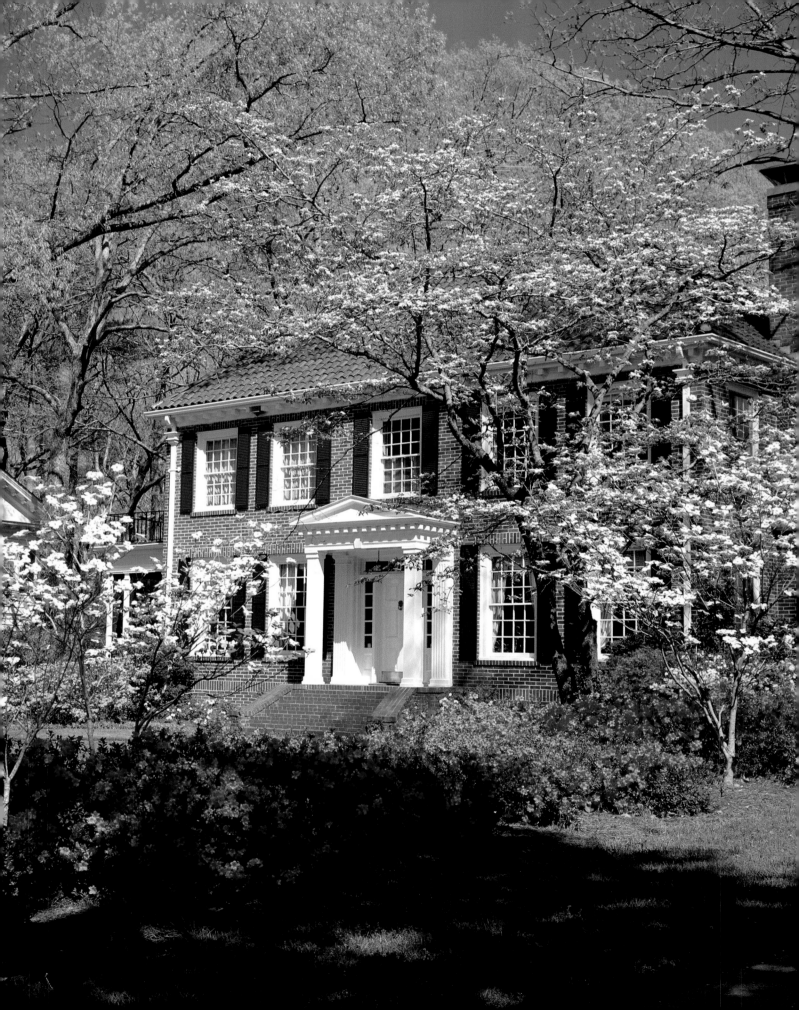

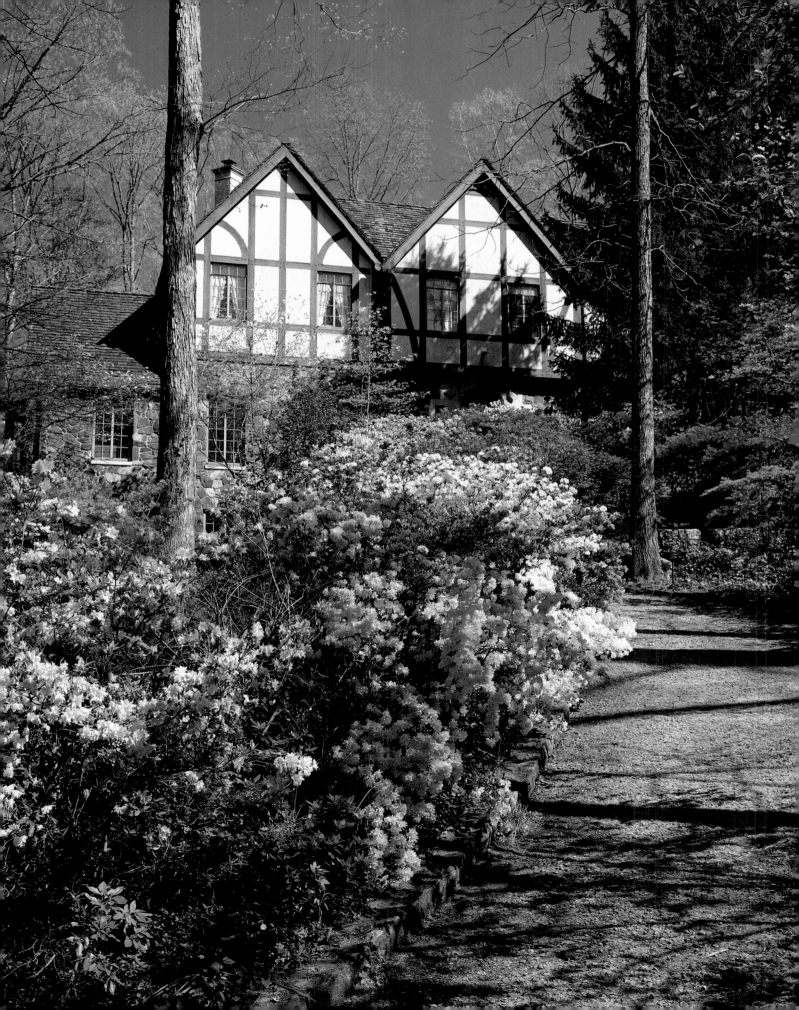

opposite: azaleas at a home in Druid Hills
top: Lake Claire
bottom and overleaf: Cator Woolford Memorial Gardens

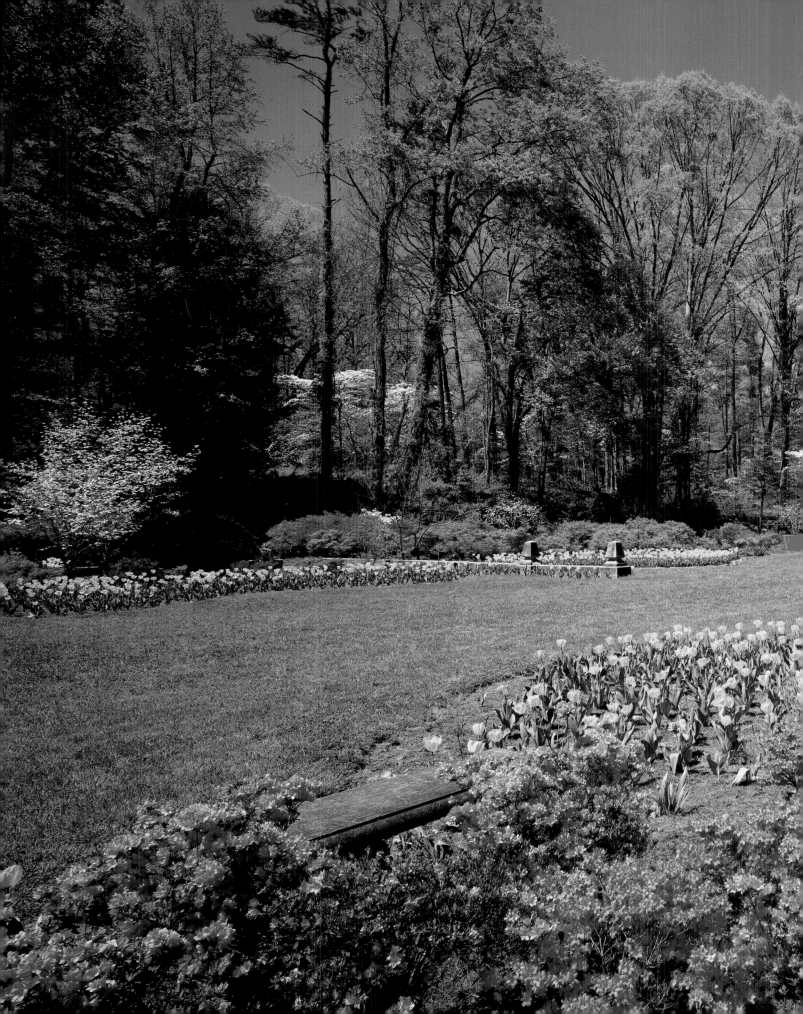

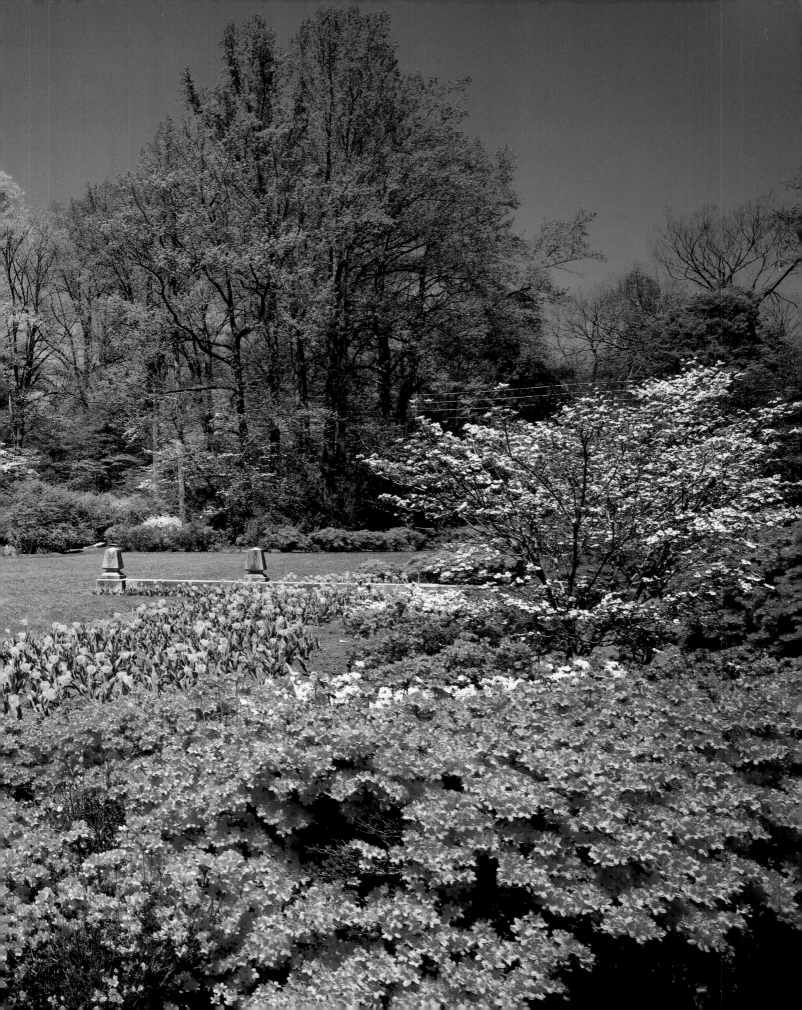

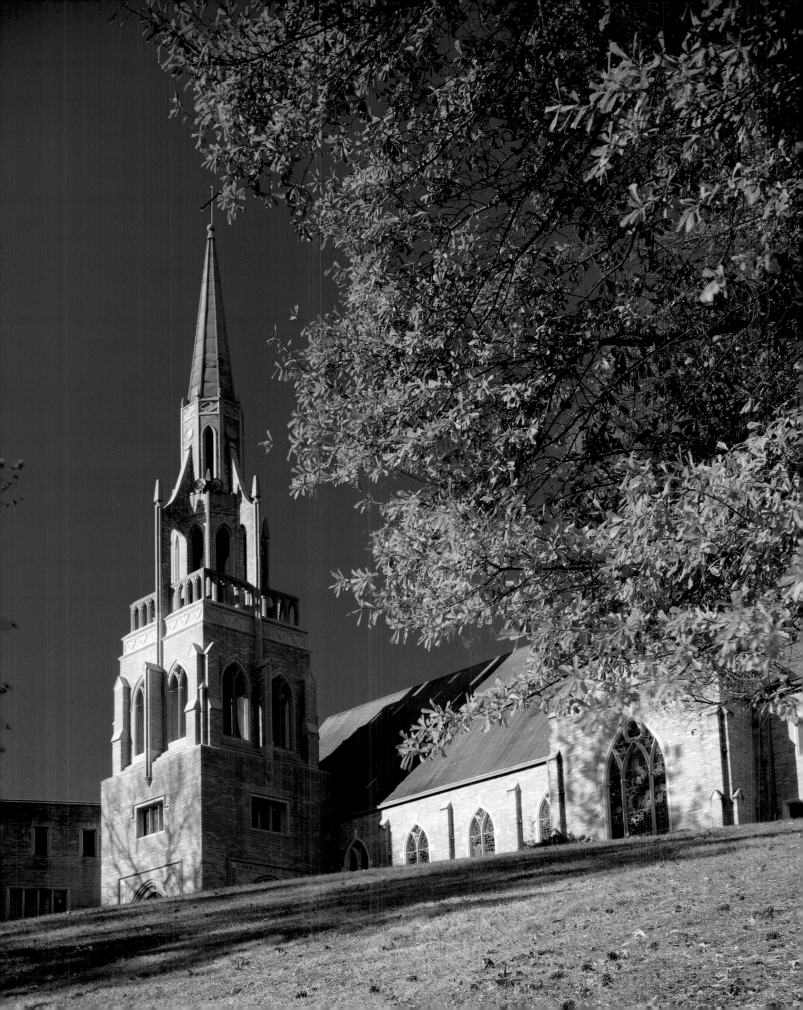

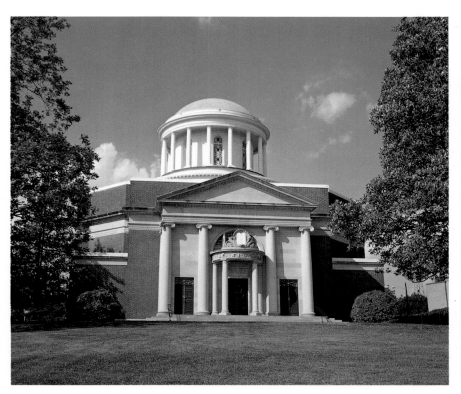

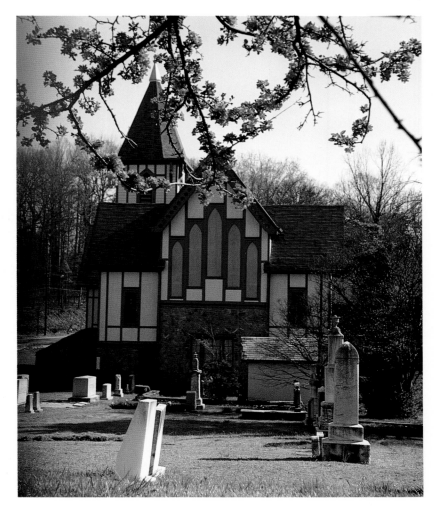

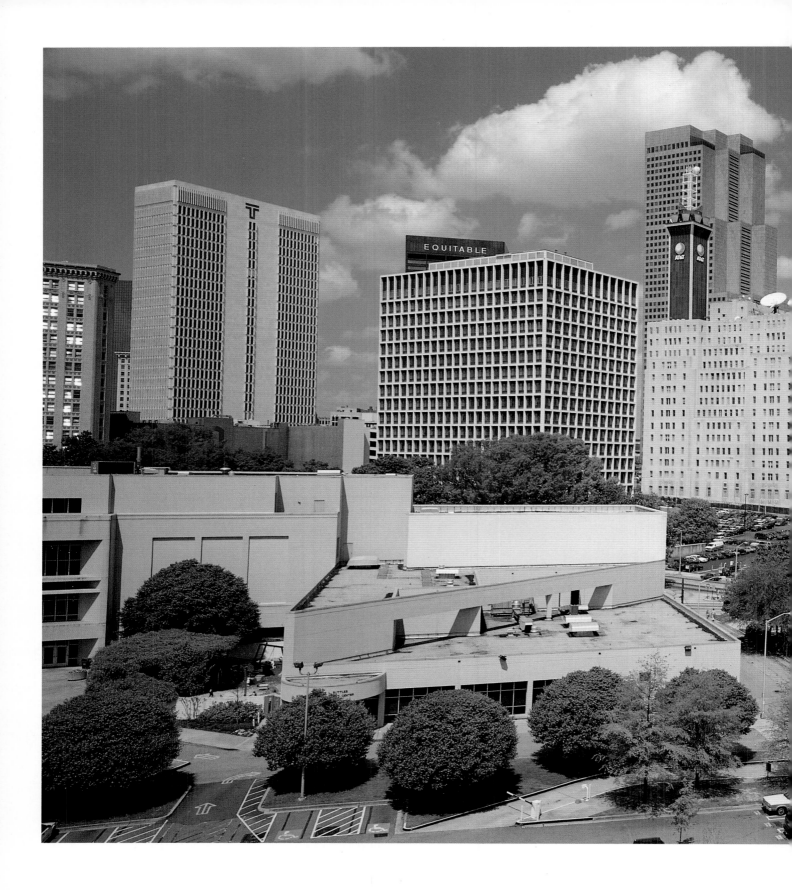

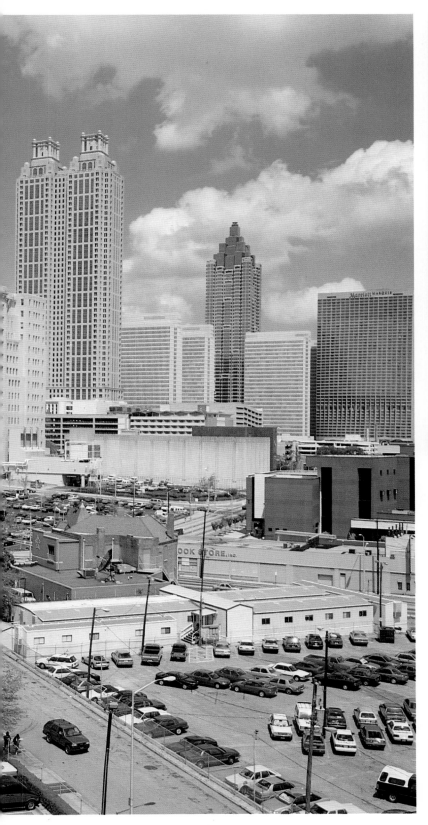

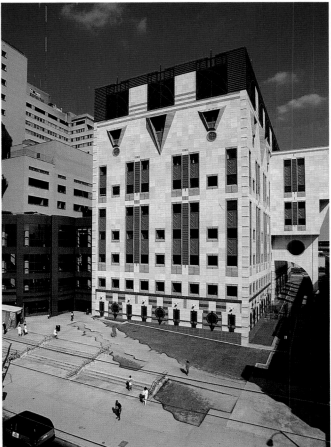

*H*enry Woodfin Grady used his gift of oratory and his position as editor of *The Atlanta Constitution* to inspire Atlantans and the rest of the country in the troubled times just after the Civil War. In his impromptu speech to the New England Society in 1886, Grady labeled Atlanta a "brave and beautiful city" and popularized the concept of the "New South" as a place ready to move beyond animosities and into a new era of reconciliation and trade.

In this speech and others, Grady promoted the agricultural and industrial development of the South and sought to improve relations with the North. Grady also played a key role in the politics of his day, and he is acknowledged as one of the founding fathers of the Georgia Institute of Technology and the Southern Baseball League. Realizing Atlanta's indigent population had no place to go for their medical needs, Grady also urged the opening of a hospital that would make medical care available to those who could not afford it. In 1882, Grady Memorial Hospital opened, named after the man who cared for those in need.

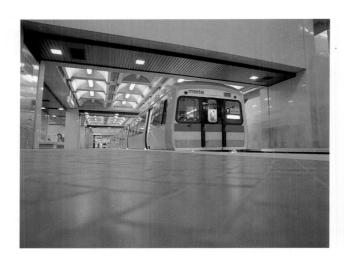

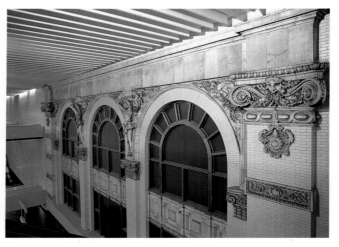

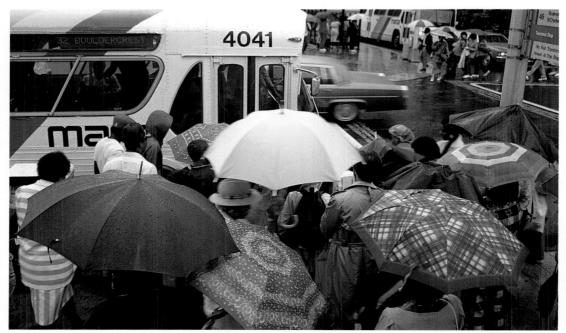

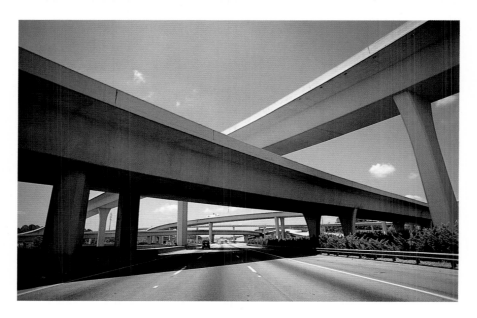

top and center: MARTA, Atlanta's rapid rail and bus system
bottom: Tom Moreland Interchange ("Spaghetti Junction")
opposite: downtown buildings on Peachtree Street

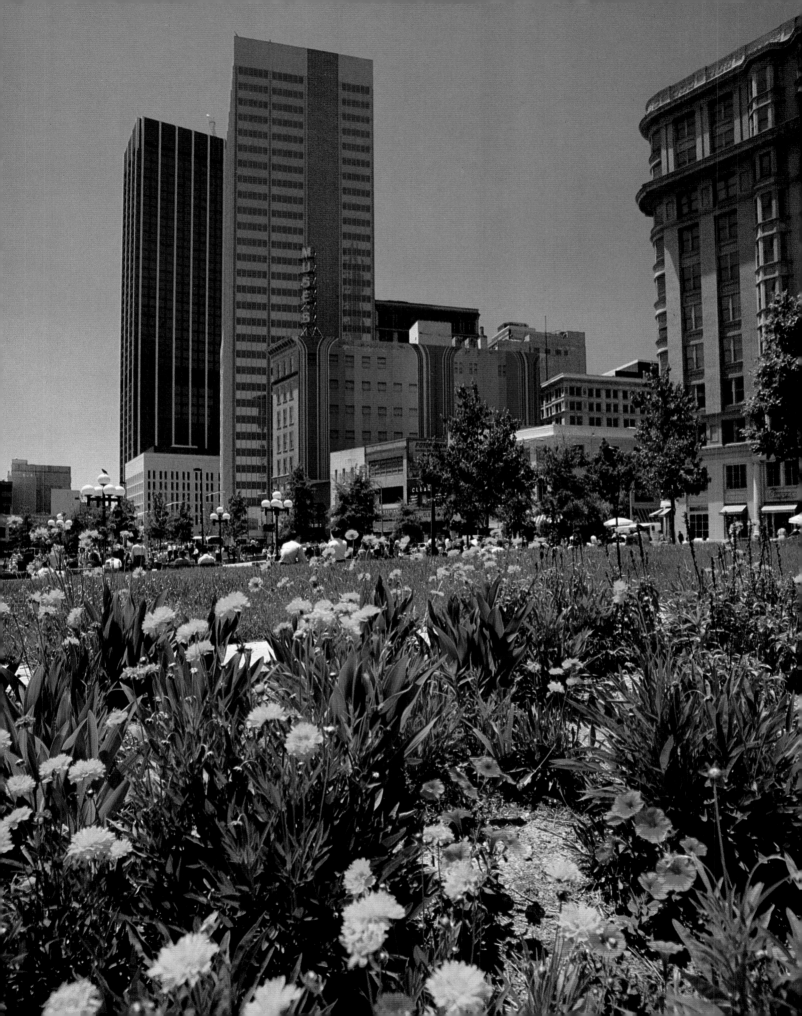

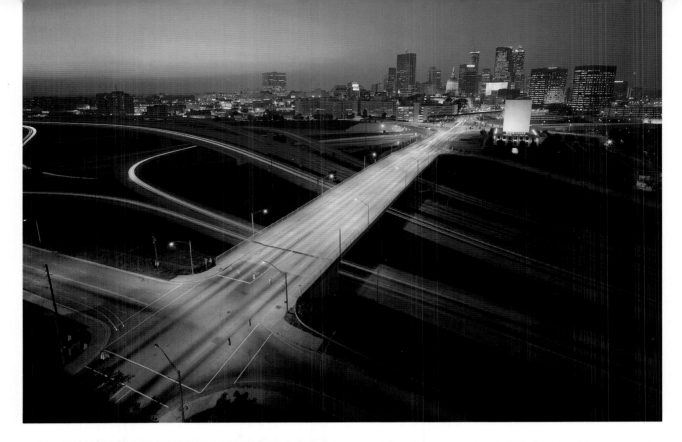

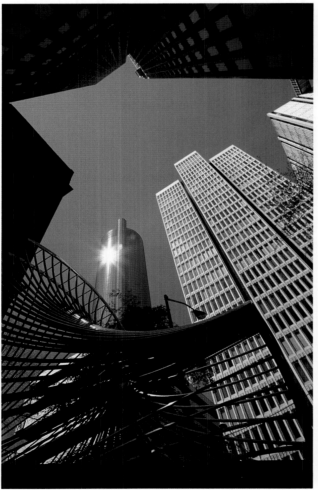

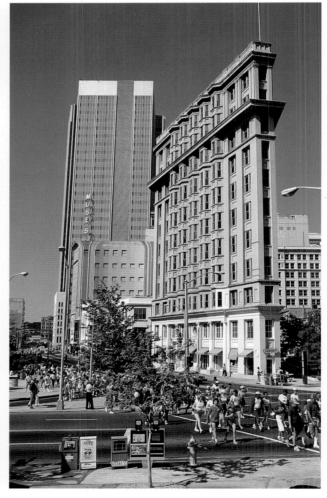

| *top:* Interstate 20 interchange, downtown
bottom left: Westin Peachtree Plaza
bottom right: Flatiron Building

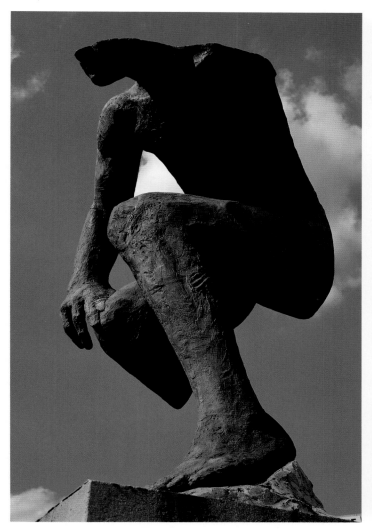

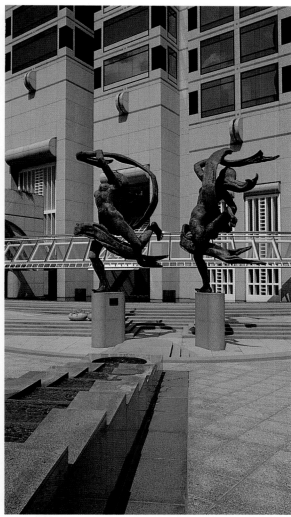

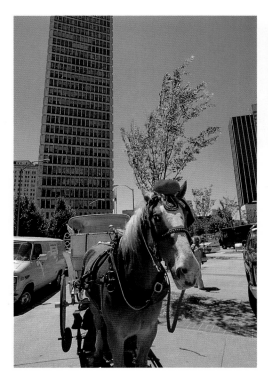

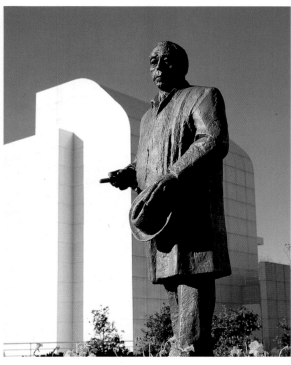

top left: Emerging, by Mark Smith

top right: Ballet Olympia, One Peachtree Center

bottom left: horsedrawn carriage, downtown

bottom right: Robert W. Woodruff statue

115

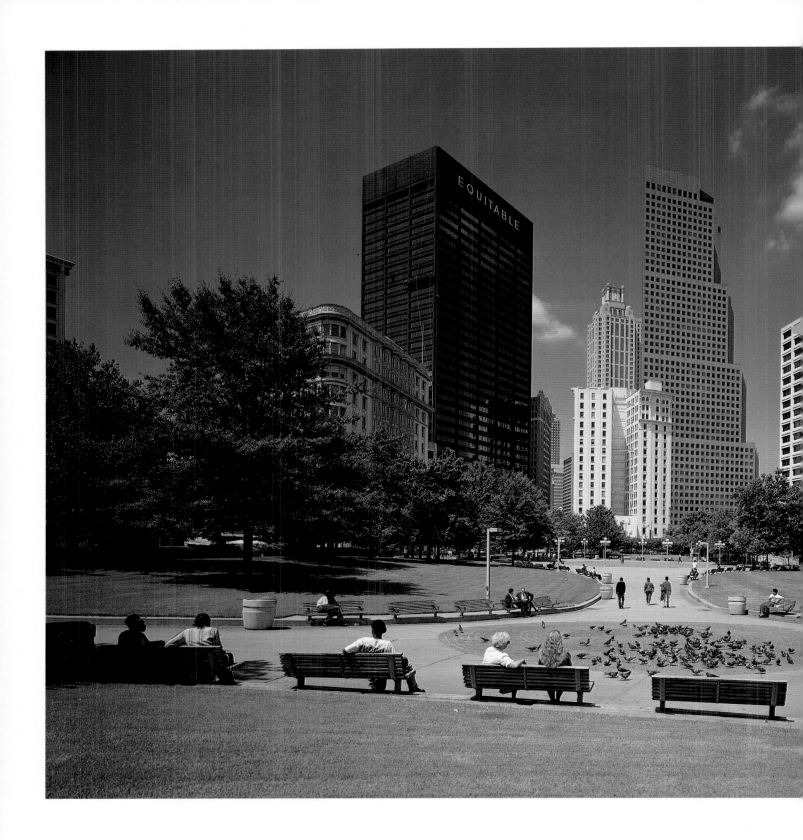

| Woodruff Park and downtown skyline

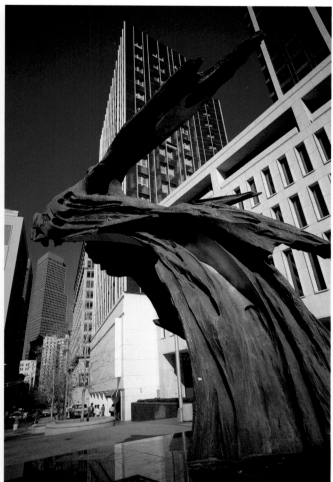

*M*ore than a century after it was chosen as the symbol for the city's seal, the phoenix remains a vital part of Atlanta's sense of self. Two modern pieces of sculpture donated to the city and based on the phoenix image recognize and celebrate Atlanta's efforts to create a "brave and beautiful" city from the destruction of the Civil War. The monument *Phoenix Rising* was donated by the Rich Foundation in 1969 and erected on Martin Luther King, Jr., Drive. This sculpture by Gamba Quirino, pictured in this book on page *iv*, portrays a woman, most likely a personification of Atlanta itself, being pulled from flames by a phoenix. One year later, an abstract bronze interpretation of the phoenix myth was created by Italian sculptor Francesco Somarni and erected on Broad Street. The bronze *Phoenix*, pictured above, now stands in the Broad Street mall at the entrance to the Five Points MARTA station.

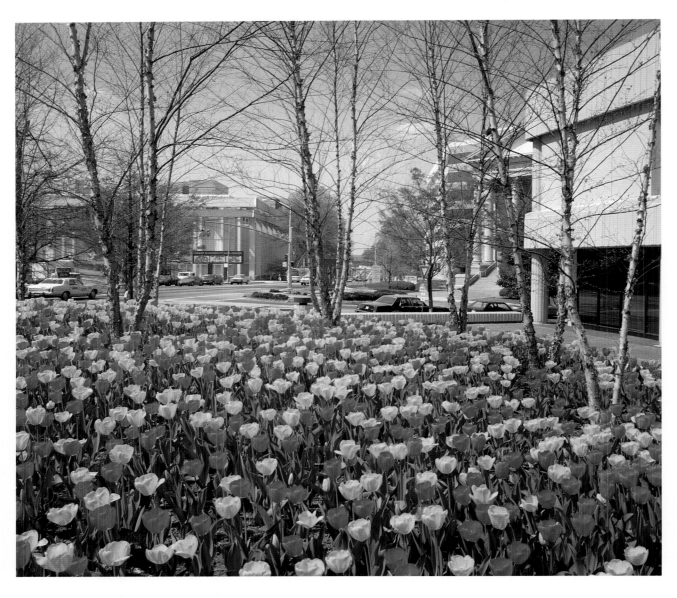

top: Woodruff Arts Center, from Colony Square at Peachtree and Fourteenth Streets
bottom: motor court, Marriott Marquis hotel
opposite: lobby and staircase, Candler building

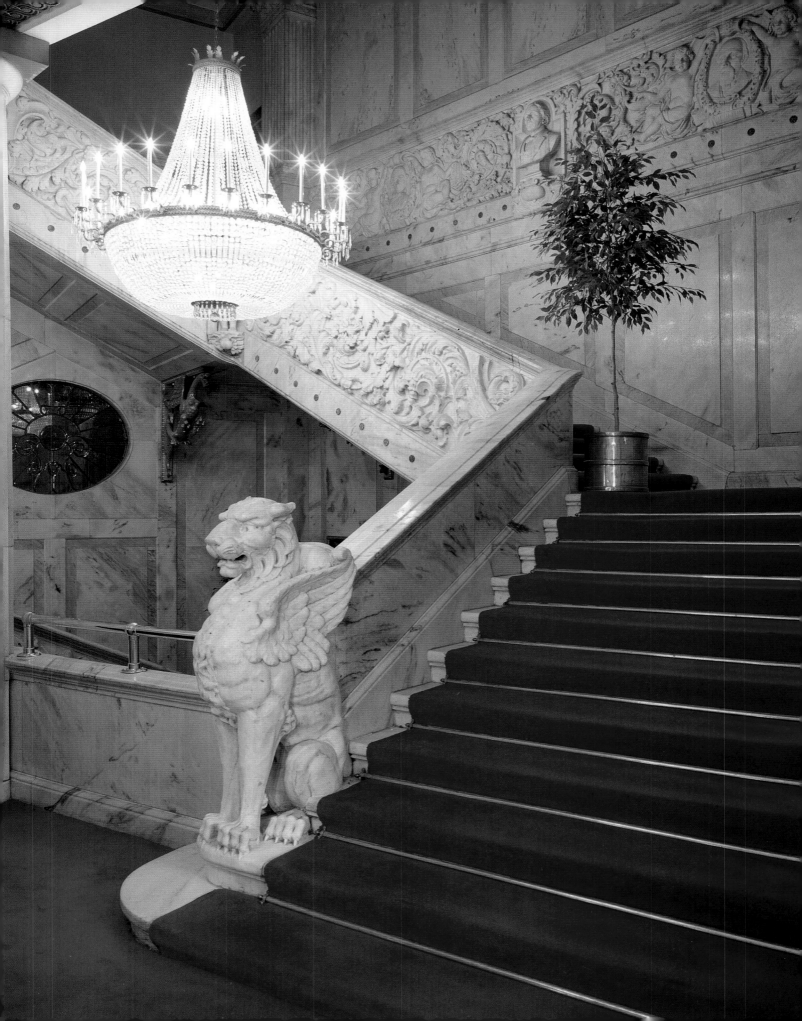

*R*obert Edward Turner III changed the course of television history and the world's idea of news coverage, all from within Atlanta's city limits. Ted Turner took his father's outdoor billboard company and built an empire called Turner Broadcasting Systems, Inc., a conglomerate that includes Cable News Network, CNN Headline News, Turner Network Television, and Turner Publishing. He also owns the Atlanta Braves, the Atlanta Hawks, and the MGM/UA film library.

Turner's career in television began in 1970 when he purchased a failing independent station in Atlanta and another in Charlotte, North Carolina, and then initiated a new programming strategy—showing reruns of sitcoms and old movies. Soon both stations were making a profit. In 1976, Turner further expanded his involvement in television when he entered the newly emerging cable industry. He began sending the signal of his Atlanta station, renamed the "SuperStation," to a satellite. The signal could then be picked up by cable companies across North America. The SuperStation's au-

dience increased exponentially, and the cable industry was off and running.

The success of this effort led to the idea of an all-news cable network. This notion was met with ridicule by American television journalism, especially because the idea came from Turner, a man completely outside the news industry. Despite the naysayers, Turner launched the Cable News Network on June 1, 1980, financing the endeavor at the risk of all he had achieved to that point. By 1985, CNN clearly was established as a major force in cable television. Turner banned all commentary by on-air reporters in 1989 in an attempt to separate CNN from the network news and focus on hard news and live coverage. This decision increased the reputation of the cable network and strengthened the public's belief in its credibility. CNN shattered the news monopoly of the then-major networks and created a communications system open to government leaders around the world. Today CNN is truly global in its coverage, offering continuous televised communication for the planet.

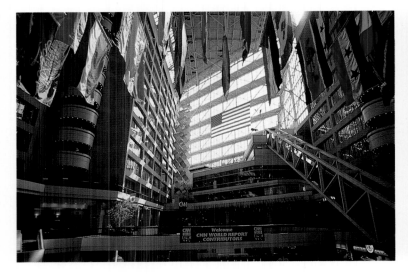

bottom left: CNN Center atrium
bottom right: Georgia World Congress Center

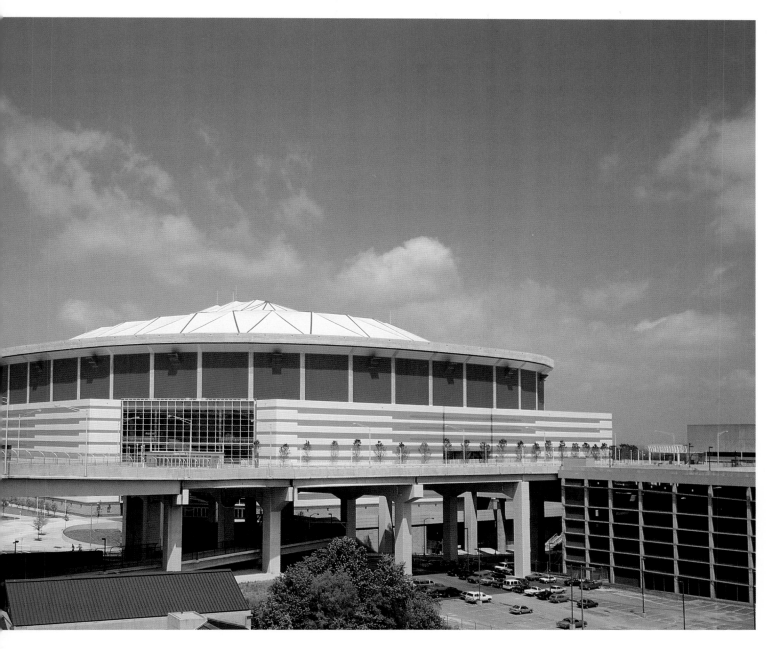

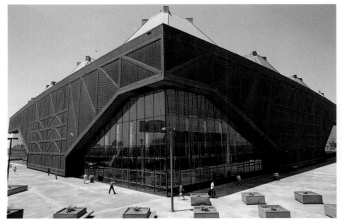

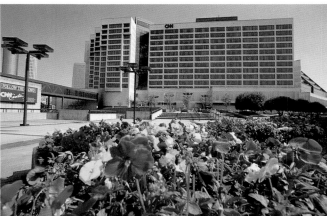

top: Georgia Dome
bottom left: Omni Coliseum
bottom right: Omni Hotel, CNN Center

121

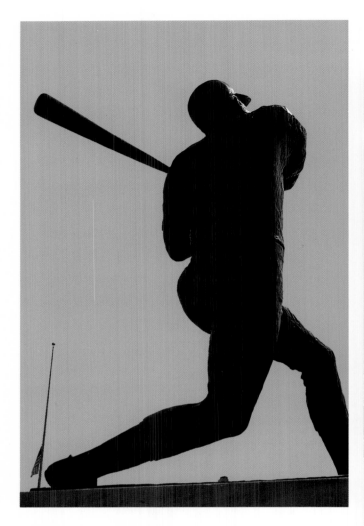

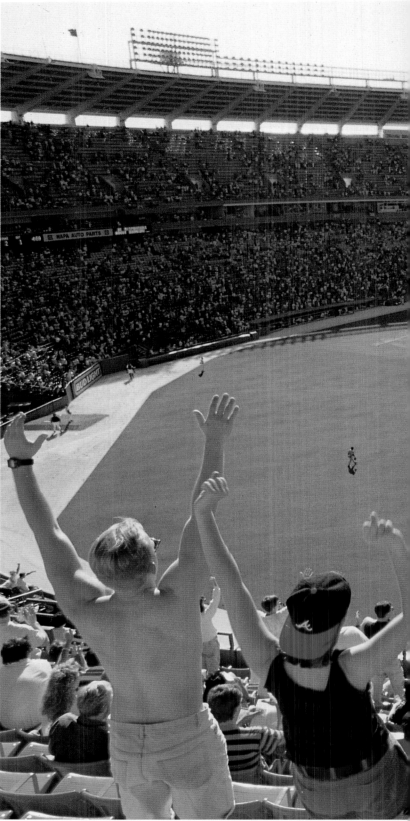

*P*rofessional baseball's greatest all-time home run hitter, Henry "Hank" Aaron began his career with the Milwaukee Braves in the 1950s. When the Braves moved to Atlanta in 1966, Aaron brought his powerful bat to the newly built Atlanta-Fulton County Stadium, where he began to accumulate world records. On April 8, 1974, "Hammerin' Hank" slugged his way into baseball history with his 715th home run, breaking Babe Ruth's thirty-seven-year record. When he retired, Aaron took with him 755 home runs, a record that might stand forever. Ed Dwight's life-size bronze statue of Aaron now stands just outside the ballpark gates, the massive swing of "Hammerin' Hank" frozen in time as a tribute to one of the most famous of the Atlanta Braves.

top left: Henry "Hank" Aaron statue, Atlanta-Fulton County Stadium
center and opposite: Atlanta Braves fans

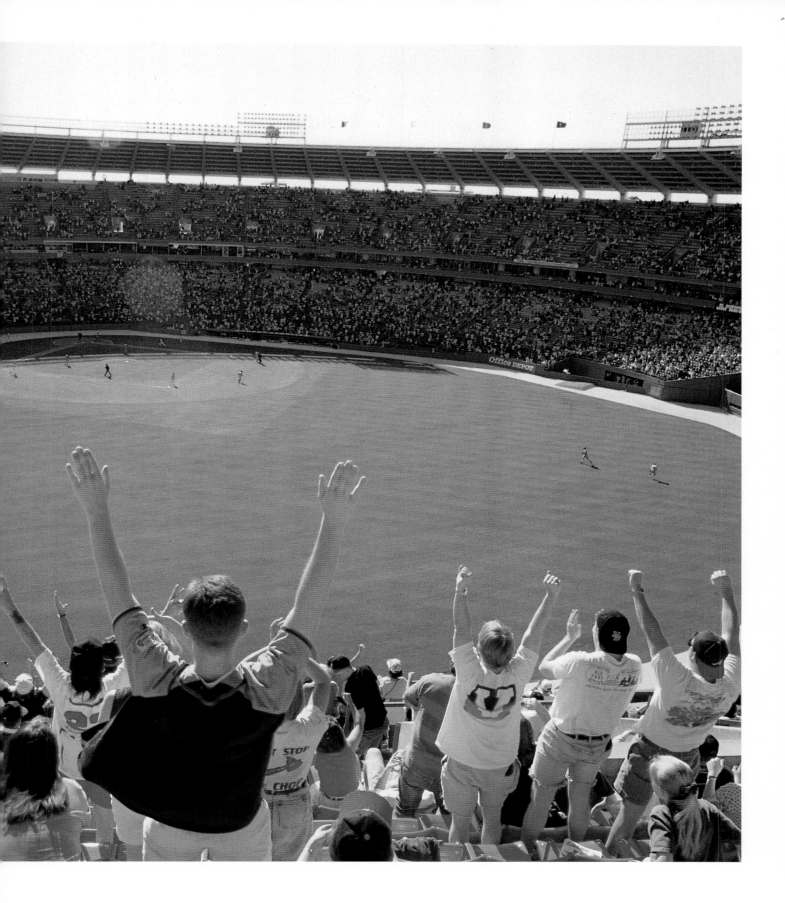

overleaf: downtown skyline 123

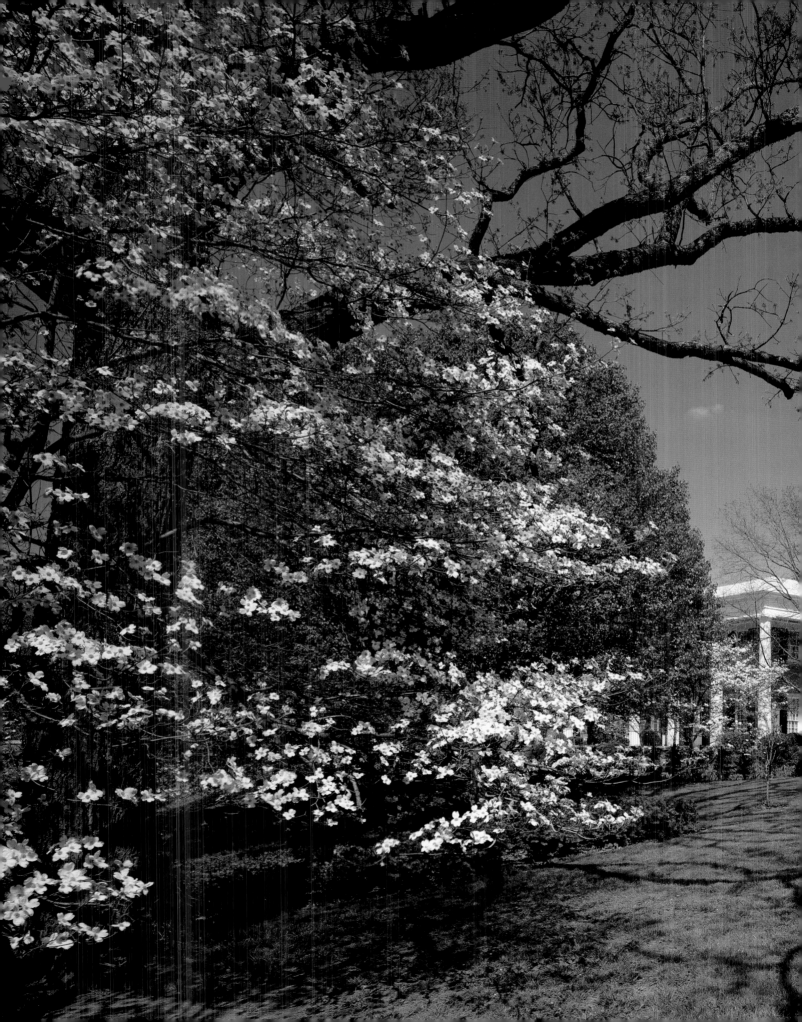

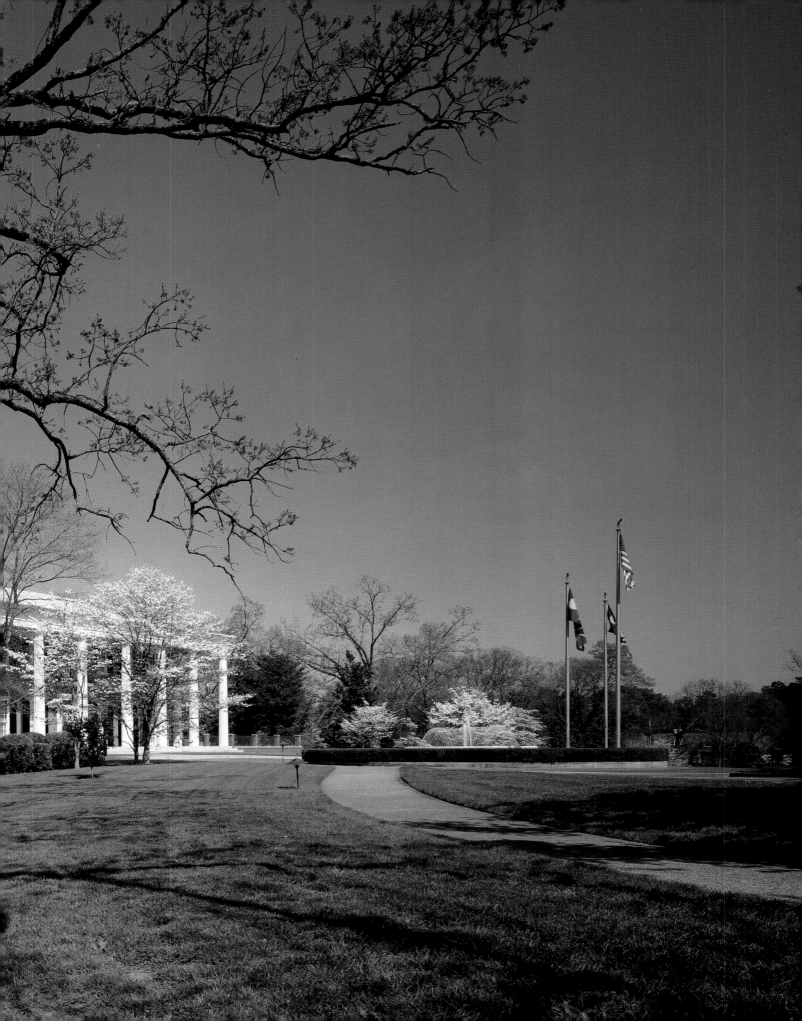

| *preceding pages:* Georgia Governor's Mansion

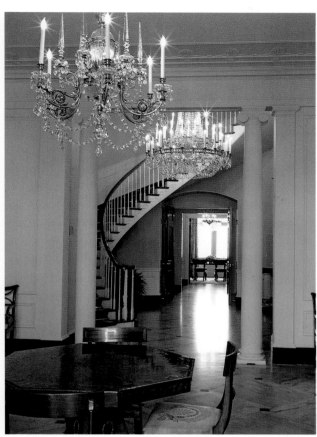

Georgia Governor's Mansion | 129
left: State Drawing Room
right: hallway and staircase

The Georgia State Capitol is one of the easiest buildings to spot in Atlanta's crowded skyline, but not because of its height, which is quite insignificant next to the fifty-story-plus skyscrapers that dominate the sky. Nor is the Capitol Building especially startling in its architecture; modelled closely after the United States' Capitol, the Georgia building seems quite traditional next to its glass-and-concrete neighbors. The State Capitol Building literally outshines its competition, because its dome wears a thin coat of Georgia gold.

Although the State Capitol Building was constructed in 1889, the dome did not receive its gilding until 1958, when the gold was brought from Dahlonega, Georgia, with great ceremony. A wagon train carrying citizens dressed in pioneer garb accompanied the forty-three ounces of gold from Dahlonega into town. A second coat of gold was applied in 1979 to refurbish the dome's shine. No matter what wonders of modern-day architecture are erected in Atlanta's future, it will be difficult to deny the capitol building and its very special dome the place of honor in the capital city's skyline.

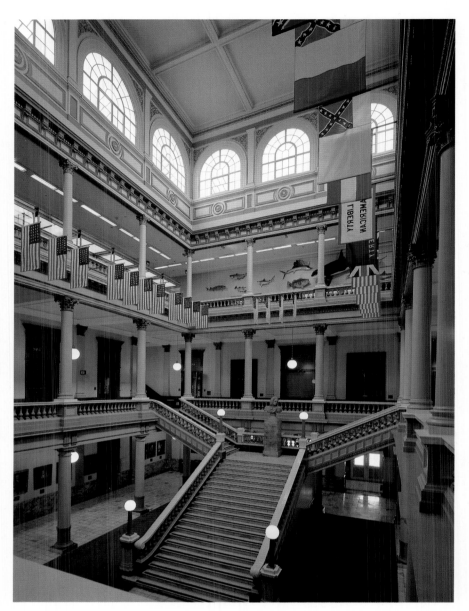

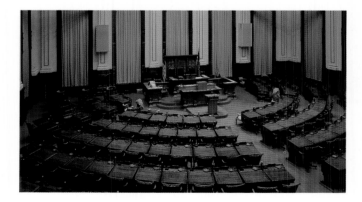

top: Hall of Flags, Georgia State Capitol Building
bottom: House of Representatives chamber
opposite: Georgia State Capitol Building

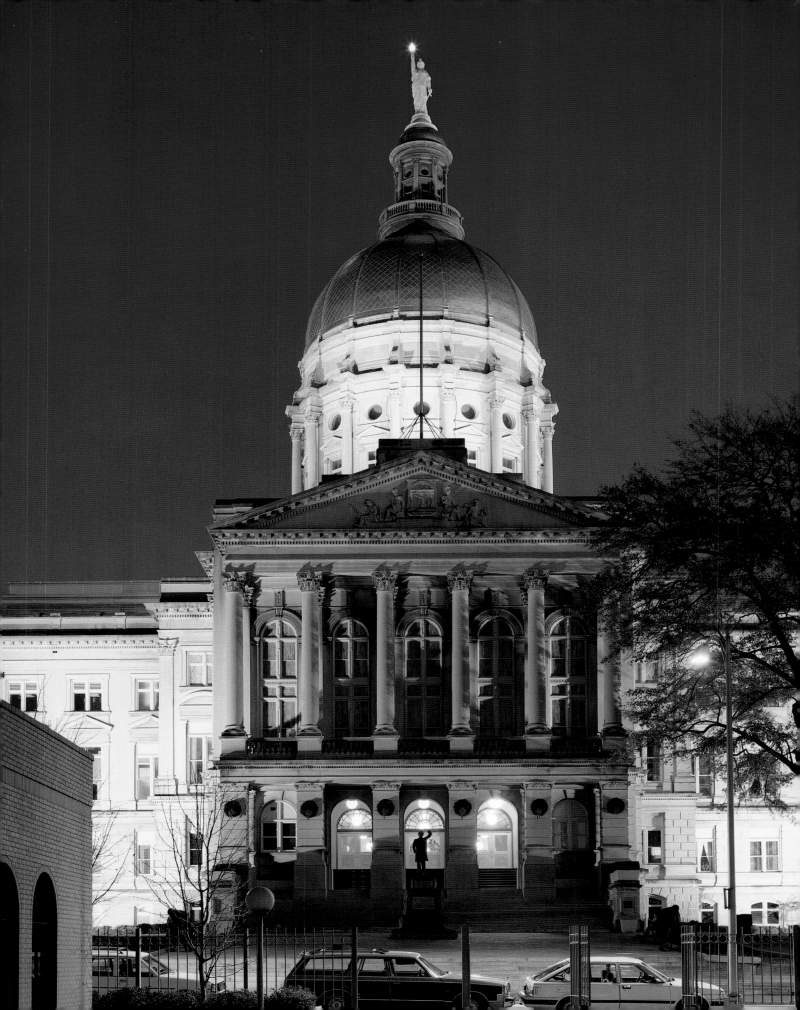

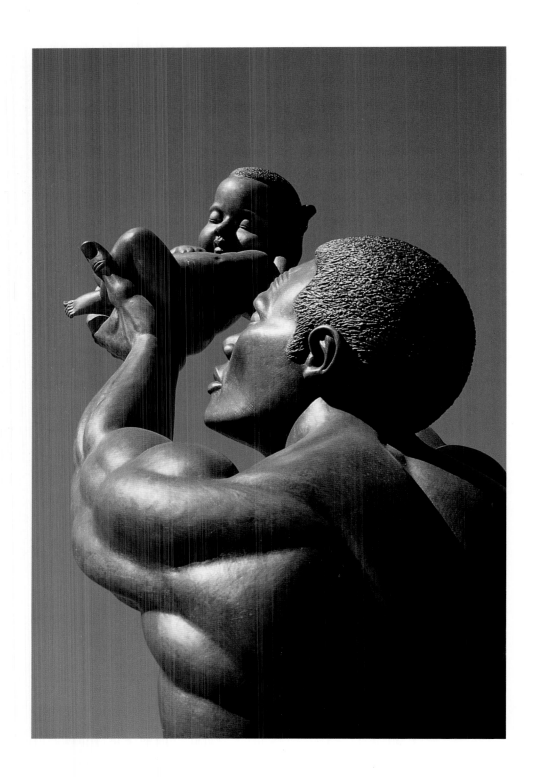

Behold, by Patrick Morelli

Notes

> *During one of the city's rare snowfalls, Atlantans turn any available object into a makeshift sled and flock to Piedmont Park.*

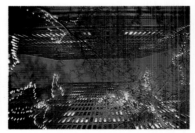

> *Sparkling lights at Peachtree Center create a festive glow on a holiday winter evening.*

Swan House, built in 1928 for Edward Inman, was designed by noted classical architect Philip Trammell Shutze and today is part of the Atlanta History Center.

Ruins of an old paper mill at Sope Creek National Recreation Area

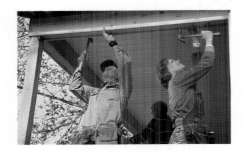

Former President Jimmy Carter, along with wife Rosalynn, are among the thousands of individual and corporate volunteers who actively support Habitat for Humanity. Founded in Americus, Georgia, Habitat builds homes for deserving families throughout the world.

*P*hotographer Peter Beney was born in Brighton, England, and lived and worked in many countries and U.S. cities before settling in Atlanta. Among his books are the photo essays *Land of the Sky*, published in 1990; *Majesty of Savannah*, 1992; *Majesty of Charleston*, 1993; and the first edition of *Atlanta: A Brave and Beautiful City*, in 1986. His work has appeared in over one hundred other books in the United States and Great Britain.

Beney has made and catalogued more than 20,000 color images which are collected in his photo library and include such subjects as nature and the outdoors, U.S. and world cities, U.S. National Parks, and foreign countries.

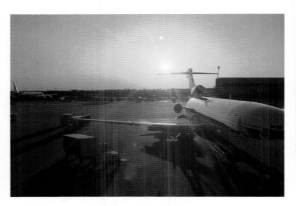

Atlanta's William B. Hartsfield International Airport is the home port of Delta Air Lines, Inc. and one of the busiest hubs in the nation.

Acknowledgments
We wish to thank the following persons and organizations for their generous assistance:

The Atlanta Ballet production of *The Nutcracker*
The High Museum of Art for permission to photograph *The Shade* by Auguste Rodin (French, 1840-1917), a gift of the French government to the Atlanta Arts Alliance
Pico Elgin for his photograph of Phipps Plaza
Rhodes Hall
Kevin Johnson of Carter Hall
The Alliance Theatre Company and staff of Sandra Deer's adaptation of Charles Dickens's novel *Great Expectations*, including Fred Chappell, director
The Atlanta History Center, for their invaluable resources and assistance in researching the history of Atlanta
Moakler Photographic Services Incorporated for their careful E6 processing of the film for this book

And finally, to all the public affairs people involved with the production of this book, many thanks for their information and support.

Selected Bibliography
Davis, Ren, and Helen Davis. *Atlanta Walks: A Guide to Walking, Running, and Bicycling Historic and Scenic Atlanta.* Atlanta: Peachtree Publishers, Ltd., 1993.

Garrett, Franklin M. *Atlanta and Its Environs: A Chronicle of Its People and Events.* Reprint of the 1954 edition, I and II. Athens: University of Georgia Press, 1969.

Mitchell, William R., Jr., and Van Jones Martin. *Classic Atlanta: Landmarks of the Atlanta Spirit.* New Orleans: Martin St. Martin Publishing Co., 1991.

Sibley, Celestine. *Peachtree Street, USA.* Atlanta: Peachtree Publishers, Ltd., 1986.

Spector, Tom, and Susan Owings-Spector, photographer. *The Guide to the Architecture of Georgia.* Columbia: University of South Carolina Press, 1993.

Thompson, Joseph F., photographer, and Robert Isbell. *Atlanta: A City of Neighborhoods.* Columbia: University of South Carolina Press, 1993.

Whittemore, Hank. *CNN: The Inside Story.* Boston: Little, Brown and Company, 1990.

Photo Credits
Atlanta Ballet photo provided by the Atlanta Ballet, page 82
Phipps Plaza photo by Pico Elgin, page 85
Atlanta Symphony Orchestra photo by Jim Fitts, page 86
Fox Theater photo provided by Fox Theater, photo by Kevin Rose, page 86
Habitat for Humanity on-site photo by Julie A. Lopez, page 136